Where's Ringo?

THE STORY OF THE BEATLES IN 20 VISUAL PUZZLES

Where's Ringo?

THE STORY OF THE BEATLES IN 20 VISUAL PUZZLES

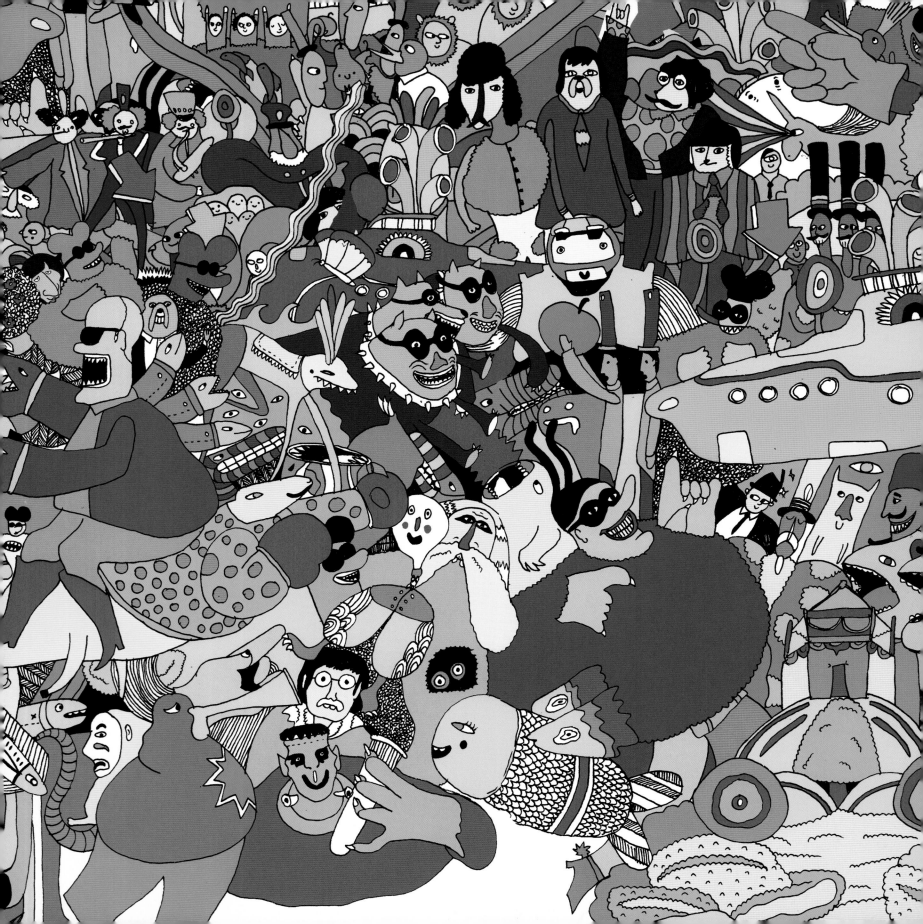

Where's Ringo?

THE STORY OF THE BEATLES IN 20 VISUAL PUZZLES

ANDREW GRANT JACKSON

ILLUSTRATIONS BY OLIVER GODDARD, TAKAYO AKIYAMA, DAVID RYAN ROBINSON

Aurum
Press

Dedicated with love to Keira

A Quintet Book

First published in the United Kingdom in 2014 by
Aurum Press Limited
74-77 White Lion Street
London N1 9PF
www.aurumpress.co.uk

Copyright © 2014 Quintet Publishing Limited.

A catalogue record for this book is available from the British Library.

ISBN- 978-1-78131-218-6

10 9 8 7 6 5 4 3 2 1
2018 2017 2016 2015 2014

This book was conceived, designed and produced by
Quintet Publishing Limited
114–116 Western Road
Hove, East Sussex
BN3 1DD
United Kingdom

QTT.WRIN

Project Editor: Bruno Vincent
Designer: Mark Hudson
Illustrators: Oliver Goddard, Takayo Akiyama,
David Ryan Robinson
Art Director: Michael Charles
Editorial Director: Emma Bastow
Publisher: Mark Searle
Publishing Assistant: Alice Sambrook

Manufactured in China by 1010 Printing
International Limited

Where's Ringo?

Contents

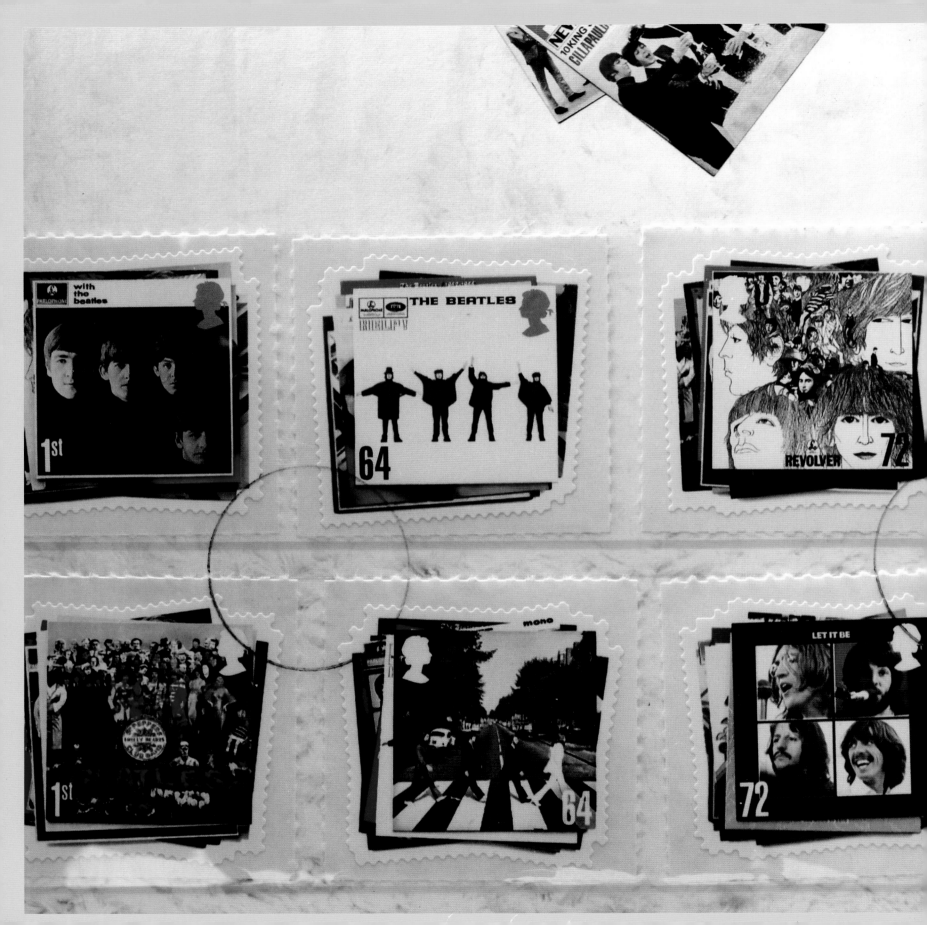

Where's Ringo?

Introduction

Ringo was born a lefty, but his grandmother made him write with his right hand. Still, he drummed left-handed, but on a right-handed kit, which meant he needed more time to roll from the snare to the tom-tom. That slight delay gave him his 'swing', and that made his drum fills distinctive. But that doesn't mean he was sloppy.

When Beatle expert Mark Lewisohn listened to thousands of hours of tapes to write *The Beatles Recording Sessions*, he found that Ringo had made only a 'handful' of mistakes from 1962 to 1970. His timing was always rock-solid. Also crucial was what Ringo's image added to the brand of the Beatles. They already had a cartoony band name and outrageous haircuts. The name 'Ringo', along with the sad eyes, was easy to remember as well, to both the press and countless fans growing in number each day. The biggest rock phenomenon besides them – Elvis – looked both handsome and cool. Paul was the 'pretty one', John and George looked cool, but Ringo brought out the mothering instinct, made them accessible, loveable. John said, 'There is something in him that is projectable and he would have surfaced with or without the Beatles.'

Ringo's self-deprecating humour made him an easy fit with the other three. His droll comic presence in their film and TV appearances brought comparisons with silent comedians like Buster Keaton. After he stole the show in the Beatles' first film, *A Hard Day's Night*, the zany spoof *Help!* centred on him, as did *Yellow Submarine* to a large extent.

John dug Ringo's unusual turns of phrase, called them 'Ringoisms', and used them for the titles of songs like 'A Hard Day's Night' and 'Tomorrow Never Knows'. John and Paul also wrote 'Yellow Submarine' and 'With a Little Help From my Friends' for Ringo's distinctive baritone. Ringo composed his own sequel to the former with 'Octopus'

Garden'. Perhaps the finest summary of Ringo's contribution came from Beatles biographer Bob Spitz when an interviewer asked which Beatle he liked best:

The true hero of the Beatles' story was Ringo Starr. He was a lovely guy, the other Beatles loved him unconditionally, he never had a bad word to say about anybody, he loved being a Beatle, he was a fantastic drummer, and he only ever wanted what was best for the group. For me he came out at the end as the character I could identify with the most. And, funnily enough, I found out that when the Beatles first came to the United States and they were selling those buttons, 'I love John', 'I love Paul', the 'I love Ringo' buttons out-sold the others five to one. So maybe Ringo has all the magic of the story. Maybe he isn't just the luckiest man alive.

'Santa, bring me Ringo'

His enormous popularity was also borne out by the flood of Ringo-themed novelty singles recorded by other artists in 1964, the first year of the Beatles' invasion of the States: 'Santa, Bring Me Ringo', 'Ringo Did It', 'What's Wrong with Ringo?', 'Treat Him Tender, Maureen (Now That Ringo Belongs To You)'. (Ringo married Maureen Cox in 1965.) Even Ella Fitzgerald sang, 'It's the Ringo Beat!'

Opposite: British stamps featuring Beatles album artwork.

When the other Beatles flew into the stratospheres of art, psychedelia and mysticism, he stayed down to earth. His two *White Album* tunes presaged the course he would take with his first solo albums: 'Goodnight' predicted the album of standards he would record for his mum (*Sentimental Journey*), and 'Don't Pass Me By' looked forward to the country album he went to Nashville to record (*Beaucoups of Blues*).

John, meanwhile, was the ultimate tortured bad boy, the rebel with the (not-so-secret) vulnerable side. He was embittered by the abandonment of his parents, then the death of his mother after he had reconnected with her, then the death of his best friend. Even his beloved uncle had died! What made his early songs more than teenybopper fantasies was his angry toughness, a wildness that coexisted with his other half that simultaneously believed in the idealistic romances he wrote. He finally found Yoko Ono to live them out with. Then, having found the love he'd been searching for, he let his band dissolve.

The core of the Beatles' explosion was the balanced chemistry between its two artistic geniuses: the frowning mask and the smiling mask – the smiling mask, of course, being Paul. Paul's mother died when he was a teen, as well. But before her death, she had been stable and loving, while John's had been a party girl who couldn't deal with motherhood. And while John never had a father, Paul had a strong one who taught his boys to always lift their caps to the ladies. Thus the Beatles had both a subversive rebel who wanted to affront authority and a happy showman who loved being the diplomat, assuring the elders that things were normal – which was how they managed to appeal to nearly everyone. John wasn't pretty enough to be a bobbysoxer pinup on his own, but for those who dismissed Paul as just one in a long line of heartthrobs, they had John as the loose cannon who threatened to sabotage the whole enterprise at any moment by shooting off his mouth. If you went really deep, perhaps Paul's

relentless optimism was forged of an even steelier resolve than John's angst.

Songwriting

Though all of their songs were credited to Lennon–McCartney until the end of the decade, after 1963 the composition was usually the product of the one who sang lead, with the other helping to polish it up. Of their No. 1 singles (in both the United Kingdom and the United States), John was the primary force behind nine, Paul thirteen, with four being a shared effort. The not-so-secret story of the Beatles is the competition between the two. Paul got the most female fans and it pushed John to write more of the early tracks. Mid-decade, Paul pulled equal, then passed him, then John caught back up.

The key was, for most of the Beatles' existence they each dug what the other was doing – which wasn't always the case with their rivals. When the Beach Boys' Brian Wilson wanted to have oblique lyrics for his 1967 album *Smile*, bandmate Mike Love didn't like them. But when John wanted to get surreal, Paul brought in some way-out sound effect mixes he'd made at home. When Elvis got into mysticism, his Memphis Mafia couldn't relate. When George did, the other Beatles followed him to India.

A decade of experimentation

George is the most enigmatic of the Beatles because while he stood in the others' shadow, some of his contributions are so essential to the '60s that it's hard to imagine the decade without him. His 12-string arpeggio at the end of 'A Hard Day's Night' gave birth to the sound of folk rock. His fascination with Indian instruments was a key component of psychedelia, opened Western minds to world music and encouraged millions of Baby Boomers to look into Eastern philosophy.

What kept their albums interesting was the constant intercutting between the four different personalities – fiery passion, elegant

melodicism, airy spirituality and the earthy guy who was happy to be there with his pals. They started trading off lead vocal duties early on in their career; when they had to play multiple shows a day in Hamburg, they all needed to take turns giving their voice a rest. In order to fill up all their stage time, they had to generate an encyclopedic knowledge of rock and R&B and blues and show tunes, and had to constantly improvise ways to make the songs last longer.

Luckily for us the Beatles' label EMI wasn't worried about oversaturating the market as labels are now; back then the group was hounded to have two albums with separate hit singles a year. To avoid burnout they turned to experiment and novelty, including new sounds like the jangle, feedback, the sitar, backwards guitars; older sounds like string quartets, brass and music hall; and new lyrical influences like Bob Dylan. Today it's hard to imagine a boy band transforming into an art rock band while still cranking out the year's biggest hits. As if 'N Sync turned into Radiohead in two years. The Beatles' omnivorous eclecticism inspired their peers to write and play anything they wanted, and the metamorphosis of the band known as the Fab Four became a shared mass epiphany.

Universal appeal

They wrote songs that expressed their own personal story but remained open enough for anyone to make their own. They chronicled their time like no other: Swinging London, the Summer of Love, the sexual revolution, psychedelia, the counterculture, meditation, the spiritual revival, the antiwar movement and the struggle for civil rights all found a way into their music. They let us see inside their world through their words and music and they inspired millions to assert their right to freedom in everything from hair and fashion to art, spirituality and politics. *Time* magazine would list them as one of the 100 most influential people of the 20th century.

The twenty chapters in this book tell the Beatles' story from their childhood in Liverpool to the break-up in 1970. In each picture Ringo has slipped away from the other band members and needs to be found. But there are also other things to spot in every illustration as well, important people and objects from each period in the Beatles' history. There is a pictorial key at the end of each chapter to help you find bonus details you might not have spotted.

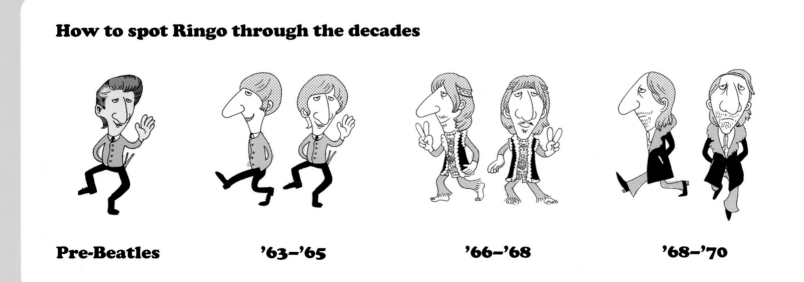

How to spot Ringo through the decades

Pre-Beatles **'63–'65** **'66–'68** **'68–'70**

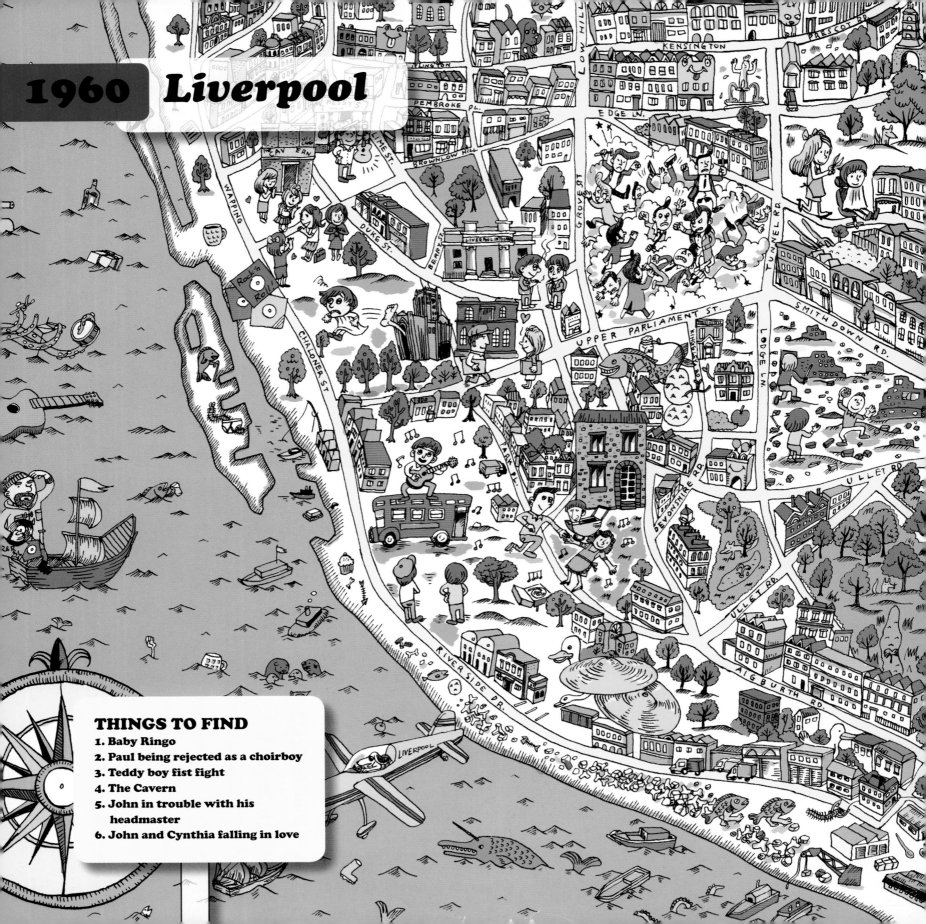

1960 Liverpool

THINGS TO FIND
1. Baby Ringo
2. Paul being rejected as a choirboy
3. Teddy boy fist fight
4. The Cavern
5. John in trouble with his headmaster
6. John and Cynthia falling in love

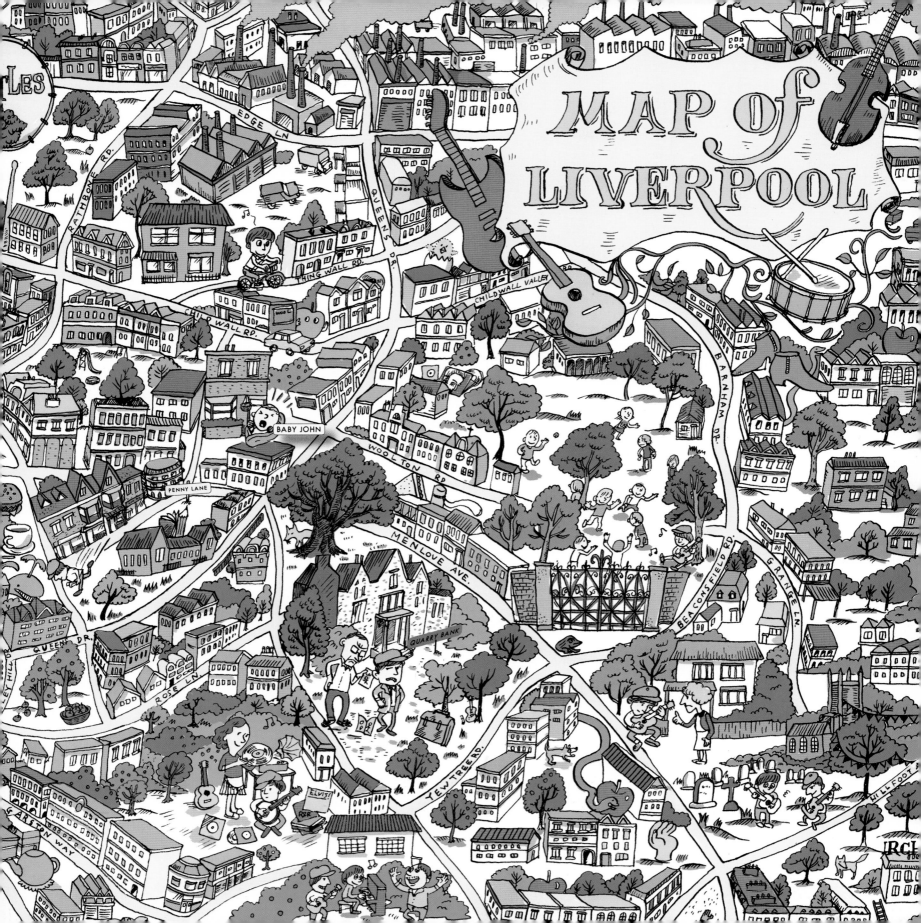

Liverpool

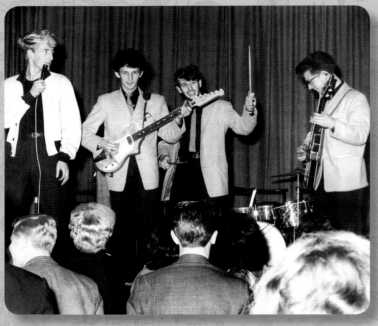

Above: Rory Storm and the Hurricanes, with Ringo second from right.

Ringo was born as Richard Starkey, on 7 July, 1940. His father left when Ritchie was three, and he'd never remember much about him. Young Ritchie played in Liverpool's World War II bomb sites but, at six, peritonitis put him in a coma for ten weeks and kept him in the hospital for a year. When he was thirteen, he would be bedridden for two years from tuberculosis – but the sanatorium set him on track for his career when they gave him drums to play.

Meanwhile, John Lennon, born 9 October, 1940, was being raised by his aunt Mimi Smith. But his mum bought him his own guitar and he started a band, named The Quarrymen because all the members went to Quarry Bank Grammar School.

After Paul McCartney (born 18 June, 1942) lost his mother Mary, who had been suffering from breast cancer, in 1956, he disappeared into music for solace and wrote his first song, 'I Lost My Little Girl', a few weeks after her death.

On 6 July, 1957, a schoolmate brought Paul to see The Quarrymen play. After the show, John was impressed that Paul knew all the words to Eddie Cochran's 'Twenty Flight Rock' and could tune a guitar. A few weeks later, he joined the band.

Paul went to the Liverpool Institute with George Harrison (born 25 February, 1943), who had heard Elvis' eerie 'Heartbreak Hotel' wafting out of a neighbour's window and felt the call to rock and roll. He auditioned but was thought too young at first. Still, George followed the band around and gradually worked his way in through persistence. Also in his favour was the fact that John's strict Aunt Mimi abhorred George's Teddy boy fashion, with garish waistcoats, pink shirts, drainpipe trousers and quiff.

On 12 July, 1958, the band went to Phillips' Sound, a small Liverpool studio, and paid to record themselves singing Buddy Holly's 'That'll Be the Day' and a Paul-George composition called 'In Spite of All the Danger' (both of which can be heard on *Anthology 1*). Three days later, an off-duty policeman killed John's mother when he hit her while driving drunk.

The primal loss that John and Paul now both shared made them feel the sorrow and euphoric catharsis of their favourite music more

deeply than the average musician, and drove them to communicate it with an intensity few could match.

John met Stu Sutcliffe (born 23 July, 1940) at art school. Together they came up with the name Beatals, which became Silver Beetles, then Silver Beatles, and finally just the Beatles. When Stu received money from the sale of a painting, John persuaded him to buy a bass and, on 7 May, 1960, Stu was in the group. Meanwhile, Ringo was already on the Liverpool music scene, in Rory Storm and the Hurricanes.

DID YOU FIND?

1. Baby Ringo

2. Paul being rejected as a choirboy

3. Teddy boy fist fight

4. The Cavern
Rock and roll was not allowed when the Cavern opened for jazz in 1957, though John slipped an Elvis song in when the Quarrymen played on January 24, 1958.

5. John in trouble with his headmaster

6. John and Cynthia falling in love

BONUS

7. Ringo's birthplace
9 Madryn Street

8. John's birthplace
9 Newcastle Road

9. Paul's childhood home
20 Forthlin Road

10. Quarry Bank Grammar School
John was caned by the headmaster on numerous occasions, sometimes for making fun of the teachers in his comic *The Daily Howl*.

11. St Peter's Church
Paul's school friend Ivan Vaughn brought him here to watch John's band the Quarrymen play. John's mother and Aunt Mimi were also there to watch the show.

12. Penny Lane
Paul and John would turn this local landmark (along with Strawberry Field Orphanage, below) into one of the most innovative double A-sided singles of all time in 1967.

13. Strawberry Field Orphanage
The distinctive gates of Strawberry Field orphanage

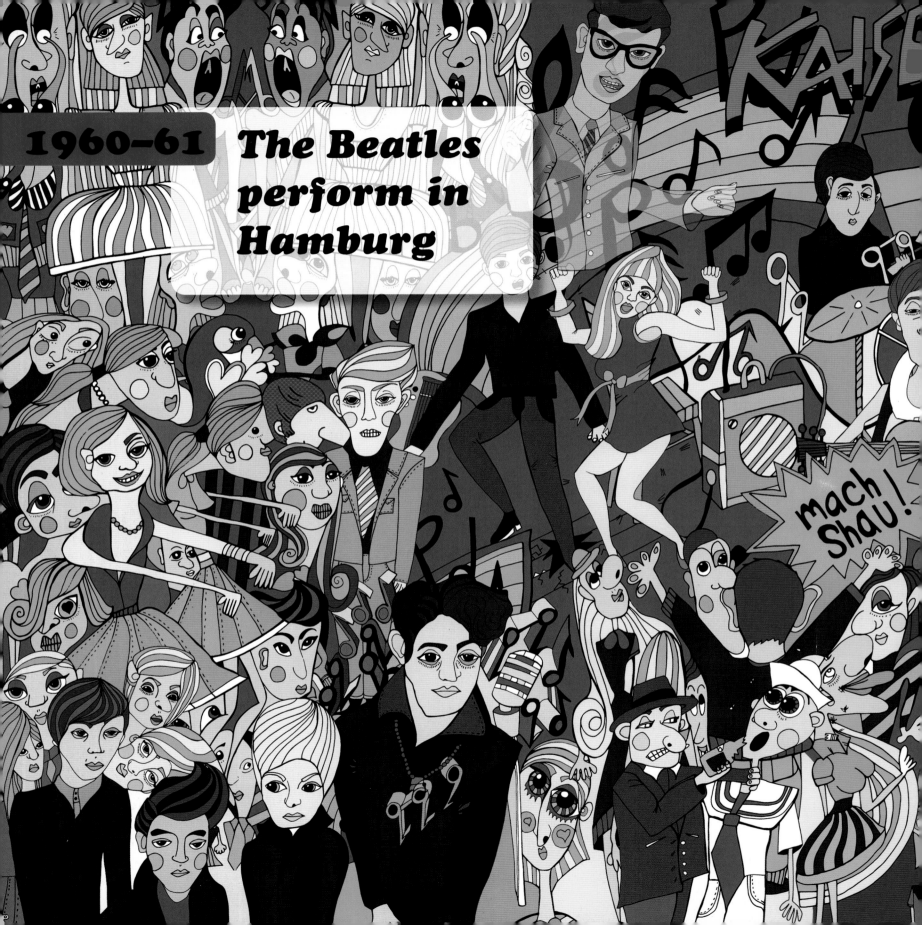

1960-61

The Beatles perform in Hamburg

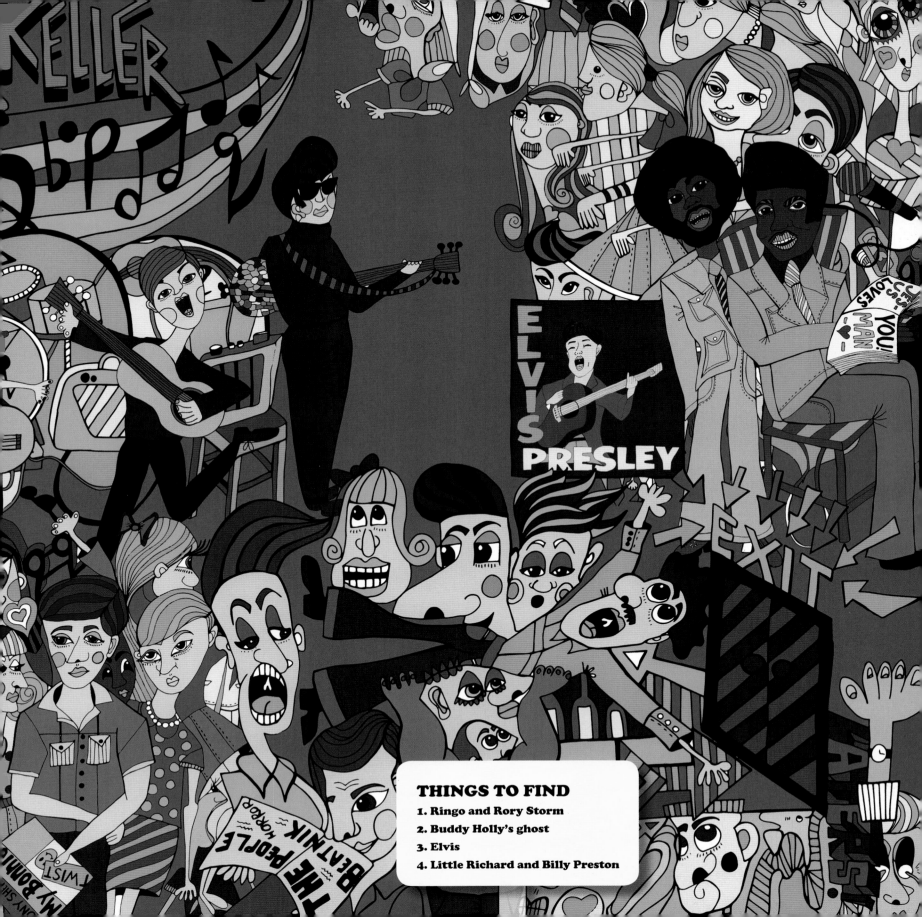

THINGS TO FIND
1. Ringo and Rory Storm
2. Buddy Holly's ghost
3. Elvis
4. Little Richard and Billy Preston

The Beatles perform in Hamburg

When they weren't at art school, John and Stu often hung out in the Jacaranda coffee bar, owned by Allan Williams, who managed bands and had success sending them to play in the German city of Hamburg. Next thing they knew, the Beatles were booked to go. But first they needed a drummer.

The band found a drummer in the Casbah Club, an all-ages/no alcohol venue in the basement of the home of Mona Best. Mona's son Pete drummed and was darkly handsome and popular with the ladies. They invited him to join and they headed to Germany.

They began playing at the Indra Club on 12 August, 1960. The club owner Bruno Koschmider was not impressed with their stationary singing style and exhorted them to 'Mach shau!' ('Make a show'). The band was obliged to play eight hours a day to sailors and other denizens of the red light St Pauli district. Often they needed to stretch out songs with twenty-minute solos and the gruelling regimen tightened them as a unit immeasurably. Beatles expert Mark Lewisohn estimates that in their first two trips to Hamburg (August–November 1960 and March–July 1961) they played over 612 ninety-minute shows in 27 weeks – with all covers, as they would not try out their own originals in front of an audience until they began playing

Liverpool's Cavern Club. When the Indra closed, Koschmider moved them to the Kaiserkeller club, where Ringo's band Rory Storm and the Hurricanes soon joined them. The Hurricanes received top billing, and more pay, and Ringo would occasionally sit in with the Beatles.

It was in Hamburg that Stu fell in love with photography student Astrid Kirchherr and left the band to stay with her in Germany permanently. Though initially reluctant, Paul took over bass and would evolve into one of the most melodic and innovative bassists of the decade.

Top left: Gene Vincent; bottom right, Buddy Holly (centre) with some of his band, The Crickets.

Astrid took many evocative black-and-white photos of the group. She gave Stu what would later be known as the Beatle haircut – a look common to German art students but exotic in England. In April 1962, the Beatles returned to play the 2000-seat Star Club, having just secured a record deal – and were devastated to learn that Stu had died a few days earlier of a brain aneurysm on 10 April.

The cause was never decisively determined. Williams believed it might have resulted from a fight after a gig in January 1961 when some Teddy boys hit Stu in the head before John and Pete could fend them off. Astrid's mother said Stu had also fallen down the attic stairs in their home. Yoko would later say that John spoke of Stu often.

DID YOU FIND?

1. Ringo and Rory Storm
Singer Storm's real name was Al Caldwell and, originally, he named his group the Raging Texans. Thus Ritchie Starkey took the name Ringo Starr because it recalled the Old West outlaw Johnny Ringo – and because he wore a lot of rings.

2. Buddy Holly's ghost
The Beatles' name was partially an ode to Holly's band, The Crickets.

3. Elvis
Even more than Buddy Holly, Elvis was the hero who made them all want to rock.

4. Little Richard and Billy Preston
'Little Richard' Penniman (reading the Bible) played Hamburg, later toured England and personally taught Paul how to shriek. Behind him sits teenage Billy (who would become a successful solo artist in his own right), who was in Little Richard's band. Later he would join the Beatles for the *Get Back*/*Let It Be* sessions.

BONUS

5. Jack Kerouac
In July 1960 the Beatles' first manager Allan Williams arranged a photo shoot of art students Stu and John for local tabloid the *People* that carried the headline 'The Beatnik Horror' (which Kerouac is holding). Perhaps the Beat Generation was another echo in the band's name.

6. Gene Vincent
The singer of 'Be-Bop-a-Lula' also played Hamburg. The Beatles adopted his look of black leather jacket and leather pants.

7. The Exis
Art students Astrid Kirchherr, Klaus Voormann and Jürgen Vollmer were the Beatles' biggest German fans. The Beatles called them the Exis because they espoused the philosophy of French existentialism and wore black.

8. The Beatle cut
Astrid gave Stu the haircut Klaus and Jürgen sported. Next George asked her to cut his hair the same way. In late 1961 John and Paul visited Jürgen in Paris and asked him to cut theirs like his.

9. Tony Sheridan
In June 1961 British pop singer Sheridan asked the Beatles to back him instrumentally on his single 'My Bonnie', which can be heard on *The Beatles Anthology 1*.

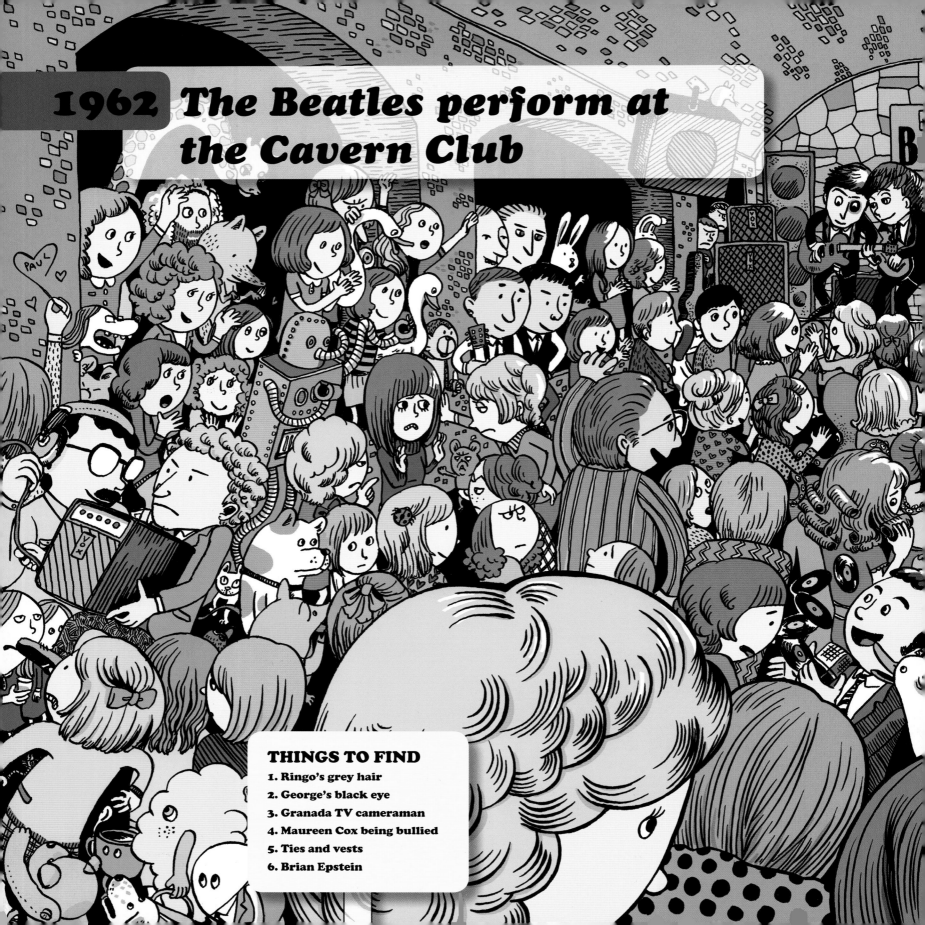

1962 *The Beatles perform at the Cavern Club*

THINGS TO FIND
1. Ringo's grey hair
2. George's black eye
3. Granada TV cameraman
4. Maureen Cox being bullied
5. Ties and vests
6. Brian Epstein

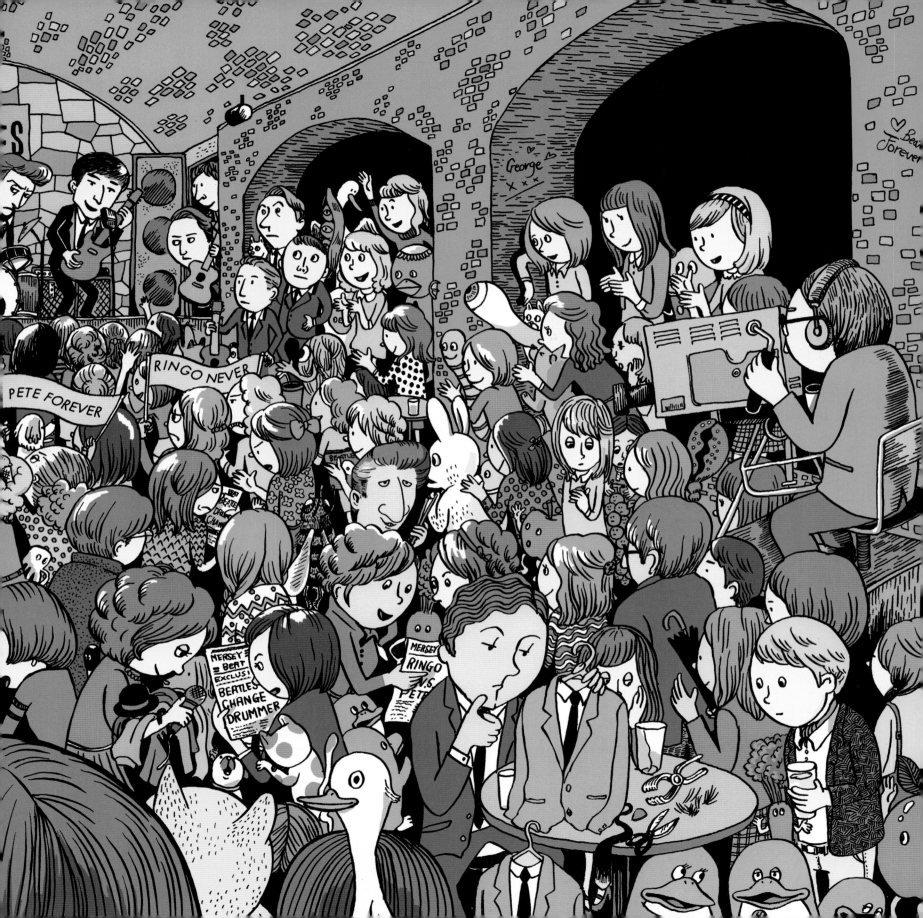

The Beatles perform at the Cavern Club

Above: Pete Best.

On 25 May, 1960, the jazz-oriented Cavern Club finally decided to have a 'Beat night' and Ringo's band played. The Beatles made their debut on 9 February, 1961 – with Pete Best on drums. They would go on to 292 performances, playing not only evenings, but often lunchtime shows as well.

The Cavern was the first place the Beatles became confident enough to try their own material. Paul remembered their first original as being 'Like Dreamers Do' (a song they would give away to the Applejacks), while John remembered it being 'Love Me Do'.

Brian Epstein (born 19 September, 1934) heard about the Beatles through a customer at his father's music shop. The group also commonly featured in *Mersey Beat*, the paper about the local music scene. On 9 November, 1961, Brian decided to check them out at the Cavern.

'And what brings Mr Epstein here?' asked the always cocky George after the show. Brian wanted to manage them but, when they met up to talk, he was unamused that all the Beatles were late – especially Paul, who had gone to take a bath. 'He may be late, but he'll be very clean', George quipped. (The 'quiet one' often had the most impudent one-liners.) They won him over.

Now managed by Epstein, they failed an audition with Decca, and then had little luck with other labels until producer George Martin of the Parlophone label (a division of EMI) agreed to record them –

except he demanded a session drummer, as Pete wasn't up to professional standards.

This was no big deal – Pete could still play with the group live. But it was at this point the band decided they wanted Ringo in, and Pete out.

Some historians say jealousy played a part. The fans screamed for Pete more than the others, at times swarming him and ignoring the other three. Others say quality was the issue. Pete hit the bass drum on every beat and couldn't play with subtlety. But Ringo was one of the top drummers in Liverpool – he even owned his own sports car at that point. The Beatles liked his ability to emulate the Latin-inflected drumming of Ray Charles' drummer Milt Turner in songs like 'What'd I Say', a style Ringo would use in 'I Feel Fine'.

The other issue was personality. John, Paul and George were thick as thieves, but Best went his own way – even forsaking the Beatle haircut because his hair was curly. With John, it was always about who could hang out with them: John and Ringo would be close for life, even living together in Los Angeles after the breakup in 1974.

It would be an interesting 'what if' to see a world where Pete stayed in the Beatles. Perhaps a Fab Four with all pretty boys would have been less accessible. Ringo was an integral part of their image, a hangdog everyman, and his popularity rivalled Paul's in America during the Beatlemania years. Could Pete have walked the canal in *A Hard Day's Night* befriending the street kid to the strains of 'This Boy', or have been followed by a Yellow Submarine in another movie four years later?

DID YOU FIND?

1. Ringo's grey hair
When he joined the band, Ringo got a Beatle cut and shaved off his beard, but in some early shots you can see he hasn't quite dyed the grey out of the hair on either side of his ears.

2. George's black eye
Ringo's first show with the Beatles was 18 August, 1962, at Hulme Hall in Birkenhead, England. The next day at the Cavern, when angry fans complained at Pete's absence, George yelled something sarcastic back and received a black eye, which necessitated him standing in profile for the first round of publicity shots they took with Ringo.

3. Granada TV Cameraman
The local TV channel filmed the Beatles playing Richie Barrett's 'Some Other Guy' on 22 August, 1962, the only footage of the group playing the Cavern.

4. Maureen Cox being bullied
Maureen had to watch her back at the club when she started going out with Ringo: jealous Beatlemaniacs scratched her.

5. Brian Epstein
Fans argue whether Brian or future producer George Martin was the 'fifth Beatle', but it was Brian who perfected their accessible image and helped them soar to fame.

6 . Ties and vests
With Paul's support, Brian got the band to drop the leather look for suits and ties – and to stop eating and swearing on stage.

BONUS

7. The Hollies
When the Beatles started touring extensively, Manchester's Hollies (named in honour of Buddy) took over their Cavern slot.

8. The Searchers
Apart from the Beatles and the Hollies, the other most enduring Merseybeat act was the Searchers, who played the Cavern in '62. Their sound would be influential on the Byrds when they created folk rock.

9. Cilla Black
In the early days, the Beatles often recommended friends to Brian to manage. George Martin would then produce them, frequently singing Lennon–McCartney songs. A prime example was the Cavern's hatcheck girl. Cilla was a belter in the Shirley Bassey mould, who had several hits with Paul's songs.

10. Mal Evans
Mal was a fan who George got a job as Cavern doorman – he was 6' 6". Together with Neil Aspinall (Paul and George's school friend who became the band's driver) Mal served as the Beatles' road crew for the rest of the decade.

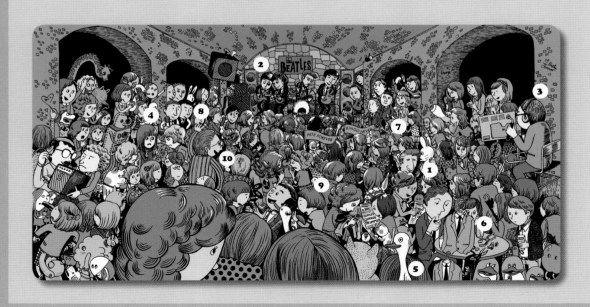

1963 *Please Please Me*

When George Henry Martin (born 3 January, 1926) agreed to produce the Beatles for EMI's Parlophone label, he had to decide whether John or Paul would be the front man.

At the time, all groups had a leader, à la Buddy Holly and The Crickets. Martin found John's voice slightly stronger but Paul's looks appealed more to female fans. Thankfully, it suddenly occurred to him that there didn't need to be one front man and the band was freed to evolve in its naturally dual-powered way.

For their first single he allowed them to perform their own originals, 'Love Me Do' backed with 'P.S. I Love You'. Released 5 October, 1962, the record got to No. 17 in the United Kingdom, probably because Brian's record store ordered most of the copies. When 'Please Please Me' shot to No. 1, they were given the go-ahead to record a full album – in one day. *Please Please Me* was recorded from 10 am to 10.45 pm on 11 February, 1963, almost completely live in the studio with few overdubs. Most of John's numbers as lead singer showed his softer side, so the plan was for 'Twist and Shout' to show his rocker side. Problem was, John had a cold and by the end of the night his voice was shot and throat sore. But it was their only chance, so at 10:30 pm John took off his shirt, sucked some cough sweets and slammed some milk, then yowled like a wildcat. Shrieking in the ecstatic crescendo, the band ripped through the wall of exhaustion with the euphoria of living their dream. The album topped the UK charts in May and would stay there until the band's second album *With the Beatles* replaced it in November. With Martin, the Beatles would unleash a stream of UK number one singles that would flow uninterrupted until 1969 (except when 'Penny Lane' was blocked from the No. 1 position by Engelbert Humperdinck's 'Release Me').

Martin played piano on many of their tracks, from the exuberant 'Rock and Roll Music' to the baroque 'In My Life'. He often shaped the group's vocal harmonies. When Paul and later

THINGS TO FIND

1. Ringo
2. Glass of milk
3. George Martin's tie
4. John's glasses
5. John's harmonica

Please Please Me

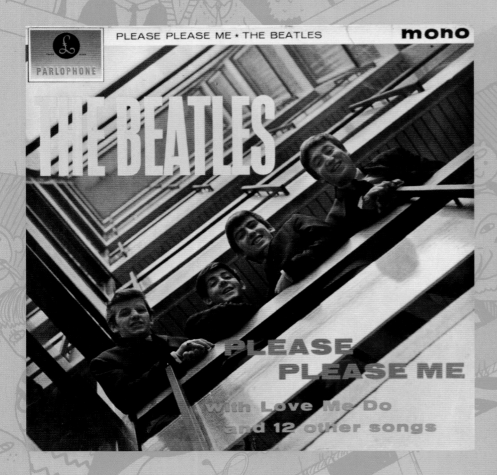

John advanced to orchestration in songs like 'Yesterday', they would hum their melodies to Martin who would in turn notate them for the session musicians. The Beatles chose not to learn how to read and write music, fearing it might disturb the creative process that was working so well. But this didn't hamper their creativity – they were so prolific that through the decade they gave away twenty songs to other artists such as the Fourmost, PJ Proby and Billy J Kramer.

Above, clockwise from left: The Beatles' Please Please Me *album cover; George Martin; Billy J Kramer.*

DID YOU FIND?

1. Ringo

2. Glass of milk
According to the Beatles' press officer Tony Barrow, there was blood in John's milk after he sang 'Twist and Shout'. They only did one take.

3. George Martin's tie
After the Beatles auditioned at Abbey Road Studios, Martin gave the recording a lengthy critique, then asked the band if there was anything they didn't like. George said, 'Well, for a start, I don't like your tie.'

4. John's glasses
Fellow students at John's art school would think him arrogant because he'd walk down the hall and not acknowledge them – but (usually) it was because he couldn't see them. He didn't like to wear his Buddy Holly-esque glasses in public.

5. John's harmonica
One of the defining aspects of the early Beatles sound is John's echo-drenched harmonica wailing. His bluesy playing featured on 12 Beatle tracks, half of them from 1963, and he considered the instrument one of the group's first 'gimmicks'.

BONUS

6. Twiggy
Widely regarded as one of the first supermodels, Twiggy (real name Leslie Hornby) became an emblem of the Swinging Sixties and Carnaby Street, London's fashion hub.

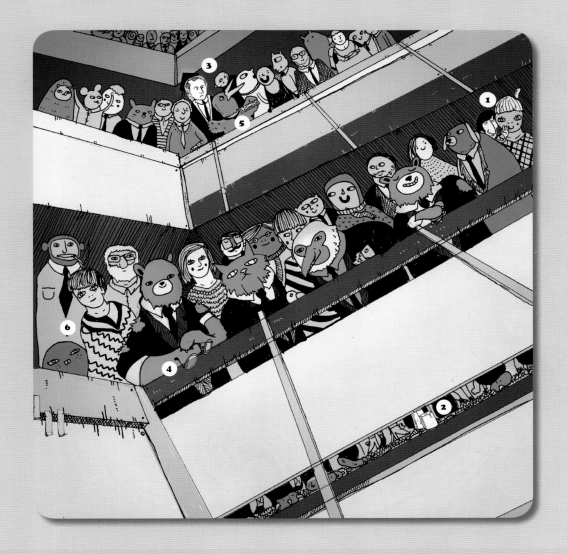

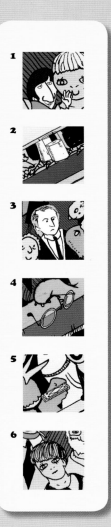

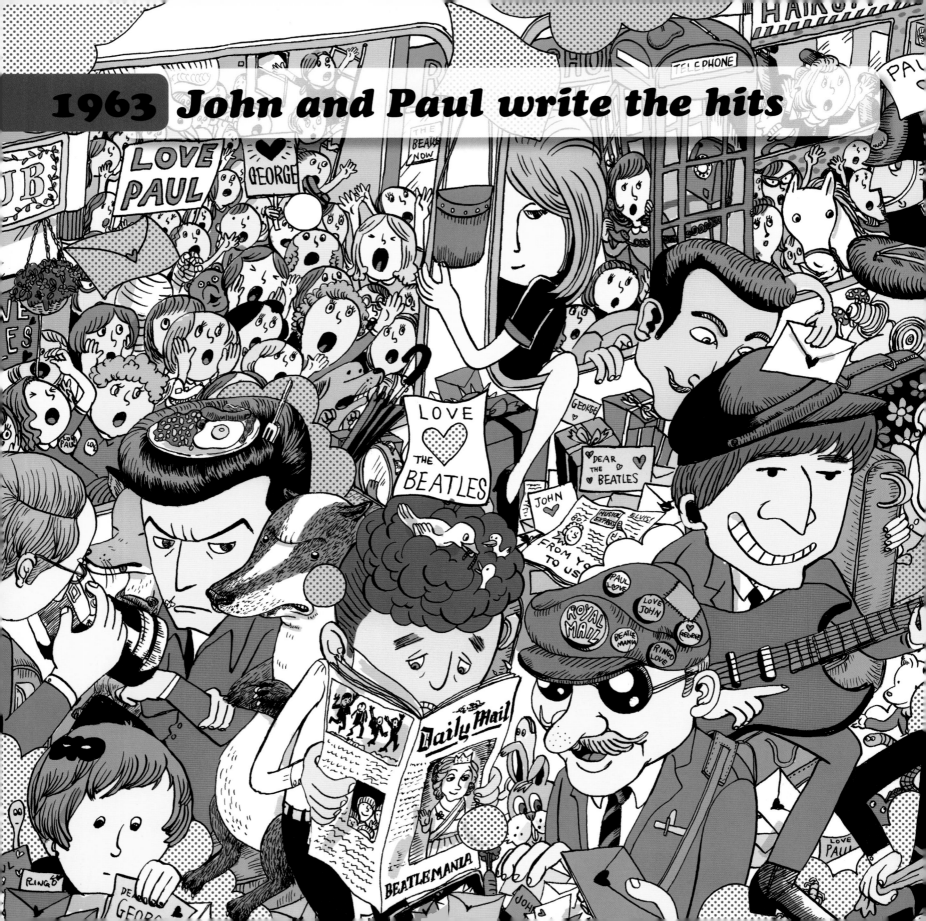

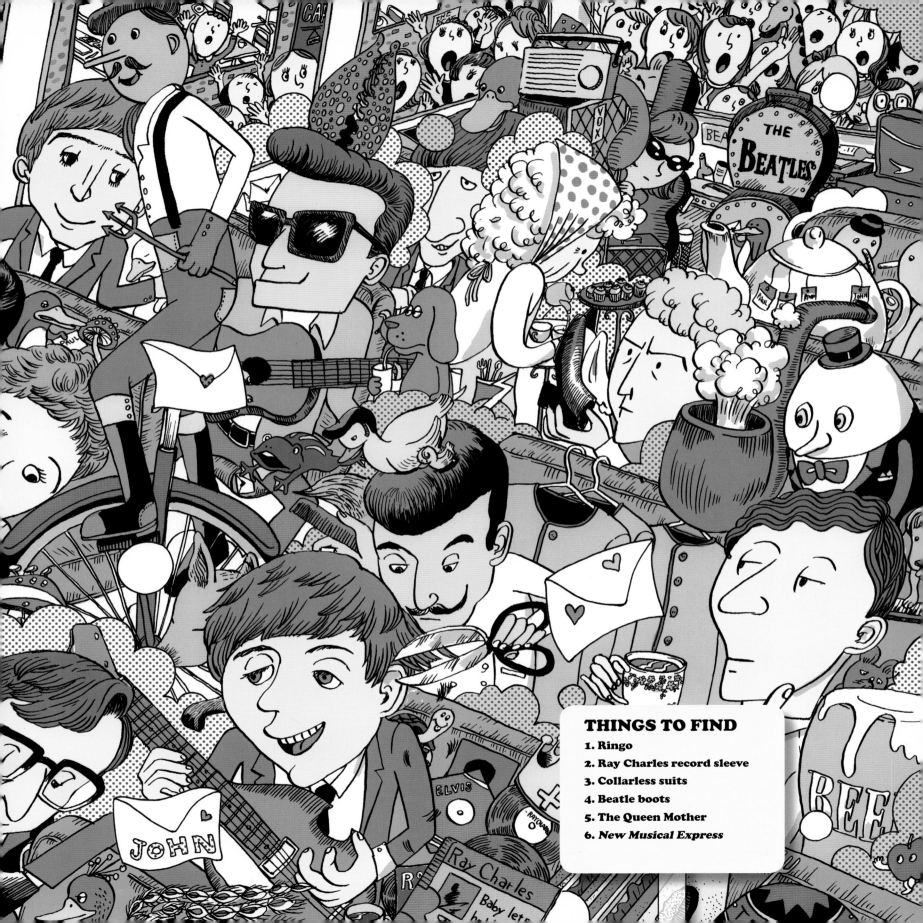

THINGS TO FIND
1. Ringo
2. Ray Charles record sleeve
3. Collarless suits
4. Beatle boots
5. The Queen Mother
6. *New Musical Express*

John and Paul write the hits

Above: Brian Epstein.

In June 1963 the Beatles got their own radio show on the BBC, *Pop Goes the Beatles*, and the BBC sessions are excellent for showing how assured the Beatles were live in the early days before the screams of the fans grew so loud they couldn't hear what they were playing.

On 13 October the band wowed the nation on Britain's biggest variety show, *Sunday Night at the London Palladium*, inspiring the *Daily Mirror* to invent the term 'Beatlemania' two days later.

On 4 November they were invited to play the Queen's Royal Variety Performance, where John deadpanned, 'For our last number, I'd like to ask your help. The people in the cheaper seats, clap your hands. And the rest of you, if you'd just rattle your jewellery.'

With his quip John showed there was more to them than a wacky haircut and crystallised their rags-to-riches mystique. Later, reporter Alexander Kendrick commented, 'Some say they are the authentic voice of the proletariat.' After the performance, the *Daily Express* ran five front-page stories on the boys and the *Daily Mirror*'s editorial gushed, 'YEAH! YEAH! YEAH! You have to be a real sour square not to love the nutty, noisy, happy, handsome Beatles.'

Throughout the year John and Paul wrote their string of UK number one singles together in tour buses ('From Me To You'), hotel rooms ('She Loves You') or the music room in the home of Paul's girlfriend Jane Asher ('I Want to Hold Your Hand'). But the two also wrote songs separately, getting together later to help each other polish their solo efforts off. After 1963 this would actually be the norm, though all their tracks would be credited to 'Lennon–McCartney'.

On their second album, *With the Beatles*, John's hauntingly bitter 'Not a Second Time' earned praise from the *Times* for its 'Aeolian cadence', the first sign of respect from the highbrow Establishment. He also tried to top his savage performance of 'Twist and Shout' with Barrett Strong's 'Money (That's What I Want)' and almost succeeded. Paul struck gold with 'All My Loving' though his 'Hold Me Tight' was half-baked. It would, however, be reconfigured as the exuberant bridge of 'A Hard Day's Night'. George placed three tracks on the album (the most he would score until 1966's *Revolver*). Included was his first original, 'Don't

Bother Me', which saw him already annoyed by the excesses of Beatlemania and was perhaps his best song until 1965's 'If I Needed Someone'. To take the opposite track from John and Paul he often penned minor key tunes and affected a gruff or ambivalent persona.

John and Paul gave Ringo their composition 'I Wanna Be Your Man', on which everyone rocked hard to make sure they weren't outshone by the Rolling Stones' cover version, which was released the same month.

DID YOU FIND?

1. Ringo
He's musing on a hair salon whizzing by outside the window. Originally the group had no idea how long their success would last, so Ringo's plan was to open a salon 'when the bubble burst'. It was an interest he shared with his future wife Maureen Cox, a hairdresser.

2. Ray Charles record sleeve
The Godfather of Soul inspired a number of Beatles songs. Guess which song title might have had its roots in Charles' 1951 R&B hit 'Baby Let Me Hold Your Hand'?

3. Collarless suits
Brian Epstein perfected the look that sold the Beatles to the world – although their hair was outrageous, their sharp dress reassured parents. Their most distinctive early outfit was the collarless suit, originally designed by Frenchman Pierre Cardin and reproduced by Beatle tailor Dougie Millings, which the band wore through most of 1963.

4. Beatle boots
These ankle-length boots with Cuban heels were created by London shoemakers Anello & Davide Gandolfi and also became an indelible part of the group's early image.

5. The Queen Mother
After the group played for the royal, she was reported to have raved, 'They are so fresh and vital. I simply adore them!'

6. *New Musical Express*
This long-running (since 1952) music publication's letter page was called 'From You To Us'. Reading it on the tour bus inspired the band's second number one single, 'From Me To You'.

BONUS

7. Tommy Roe
As the group crossed the UK in four non-stop package tours in 1963, they consistently became more popular than the headliners. American Tommy Roe (who had a hit with 1962's 'Sheila') threatened to quit if the Beatles were allowed to close the show instead of him.

8. Roy Orbison
Orbison, on the other hand, was much more gracious and swapped positions with the Fabs on the bill. In 1988 George would form the Traveling Wilburys with him, Bob Dylan, Tom Petty and Jeff Lynne. John initially composed 'Please Please Me' to be sung in Orbison's style, then the boys got a crash course in master songwriting when Orbison wrote 'Pretty Woman' in the back of the tour bus.

9. Chris Montez
Originally the co-headliner with Roe, Montez would rip off his shirt to try to hold the crowd's attention but still couldn't stop the band's ascendancy.

10. Helen Shapiro
The 16-year-old singer had recently starred in a movie about the UK jazz craze, *It's Trad, Dad* (1962), the first feature by future *A Hard Day's Night* director Richard Lester. She toured with them and was excited just to watch John and Paul compose.

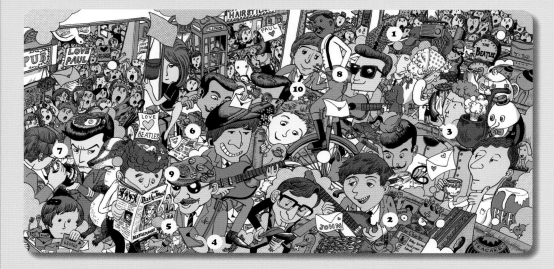

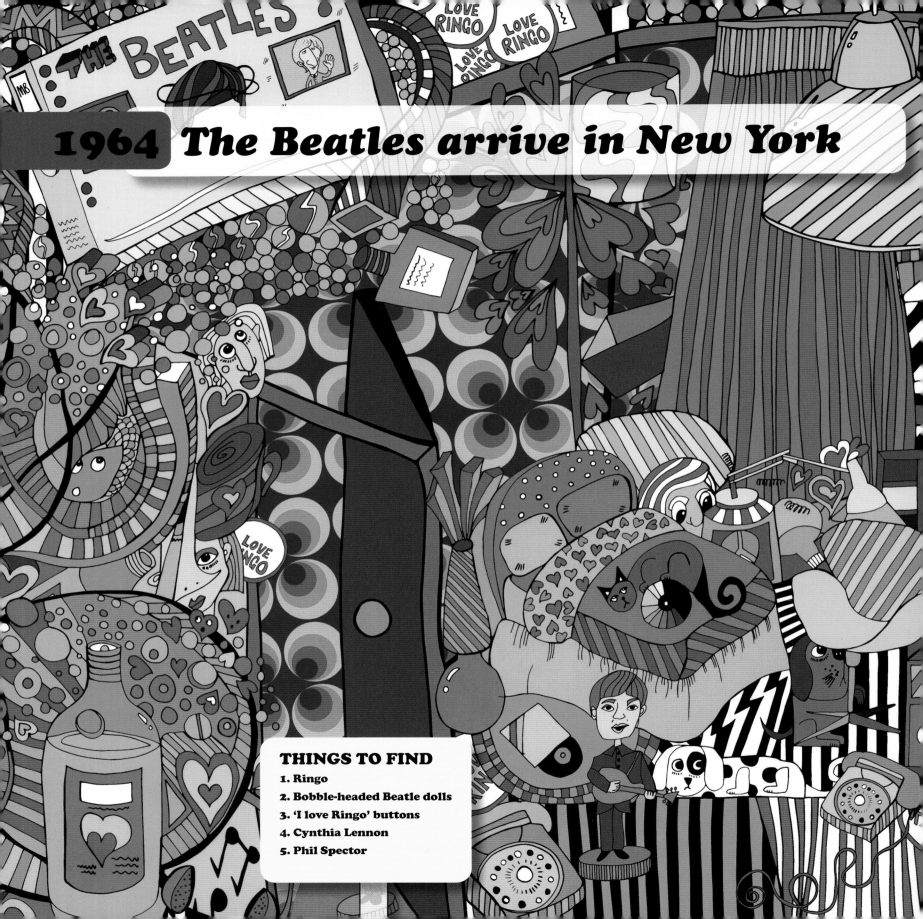

1964 The Beatles arrive in New York

THINGS TO FIND
1. Ringo
2. Bobble-headed Beatle dolls
3. 'I love Ringo' buttons
4. Cynthia Lennon
5. Phil Spector

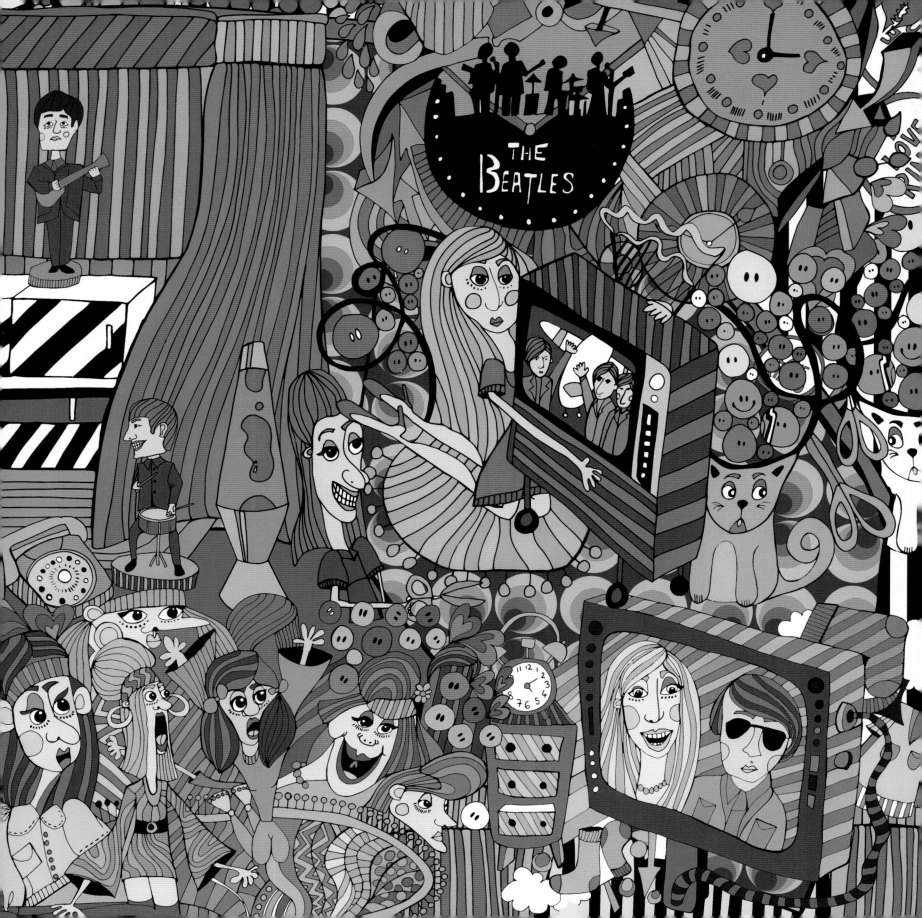

The Beatles arrive in New York

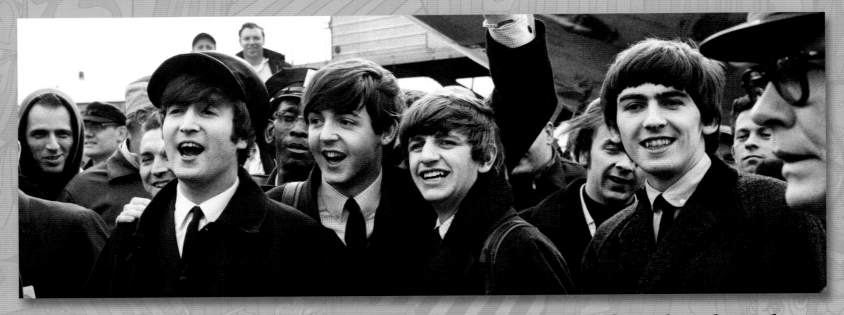

In 1963 most of America had not heard of the Beatles. The American branch of the Beatles' label, Capitol Records, had declined to release their singles, leaving them to flop on the small labels Vee-Jay and Swan. Vee-Jay couldn't even be bothered to spell the band's name correctly – the 'Please Please Me' single said it was by 'The Beattles'.

Their luck changed when TV host Ed Sullivan happened to be in Heathrow Airport on 31 October at the same time the Beatles returned from Sweden. Witnessing the airport besieged by Beatlemaniacs, Sullivan decided to book the group. Thus Capitol decided to release 'I Want to Hold Your Hand' and gamble $50,000 on a major US publicity blitz.

On Friday 7 February, 1964, the Beatles arrived at New York's Idlewild Airport, which had just been renamed John F Kennedy Airport following the president's assassination the previous November. The Beatles' merchandiser worked with the local radio stations to offer a free T-shirt and one dollar to everyone who showed up, so the observation decks were packed with fans skipping school. The hard-bitten New York journalists were gunning for the foreigners with the suspect haircuts but, by now, the Beatles had honed their repartee with reporters for over a year back home.

Journalist: 'What do you think of the comment that you're nothing but a bunch of British Elvis Presleys?'

Ringo (shaking like Elvis): 'It's not true! It's not true!'

Journalist: 'Are you going to get a haircut at all while you're here?'

George: 'I had one yesterday'.

Ringo: 'You should have seen him the day before'.

Journalist: 'Why does it [their music] excite them [the fans] so much?'

John: 'If we knew, we'd form another group and be managers'.

73 million people watched the group's 9 February appearance on *The Ed Sullivan Show* at a time when the US population was 192 million. Paul sang 'All My Loving', 'Till There Was You' and 'I Saw Her Standing There'. The band also performed 'She Loves You' and 'I Want

to Hold Your Hand'. For John's first close-up, a subtitle read, 'Sorry girls, he's married'. John got his chance to shine on their second live *Ed Sullivan Show* appearance on 16 February (Brian Epstein had managed to negotiate them three consecutive appearances), where the doo-wop-influenced 'This Boy' displayed his powerful vocal range. Musicians across the nation were impressed that the Beatles were actually playing live; they could tell since the songs did not sound exactly like they did on record.

DID YOU FIND?

1. Ringo
He's on the cover of the Flip Your Wig board game by the Milton Bradley Company.

2. Bobble-headed Beatle dolls
The Beatles' manager Brian Epstein licensed the merchandising rights for only a 10 per cent cut, but in America the merchandise suddenly looked likely to generate far more money than the records. Brian went to court to get a better deal but the litigation scared off big distributors and the Beatles probably lost more than $100 million.

3. 'I Love Ringo' button
They outsold the other Beatle buttons five to one.

4. Cynthia Lennon
Cynthia Powell met John in art school and was his emotional support in the aftermath of his mother's death and the death of Stu Sutcliffe. When she became pregnant with Julian in summer 1962, John married her. Manager Brian tried to keep her and Julian a secret for fear of losing fans, but the British press quickly discovered them. She accompanied John to their New York debut and added to his wholesome image as the group's leader.

5. Phil Spector
Spector produced some of the Beatles' favourite records of the early '60s. The astute (but later dangerous and troubled) maestro made it a point to be on their first plane trip to America. After the group broke up he produced John and George's first solo records.

BONUS

6. The teen who cut off a piece of Ringo's hair
Beverly Markowitz snuck into a cocktail party at the British embassy and snipped off a piece of Ringo's hair, which made Ringo 'ruddy mad'. But recounting the incident to the press, he shrugged, 'Tomorrow never knows', cracking John up and inspiring the title of the Beatles' most 'way out' song.

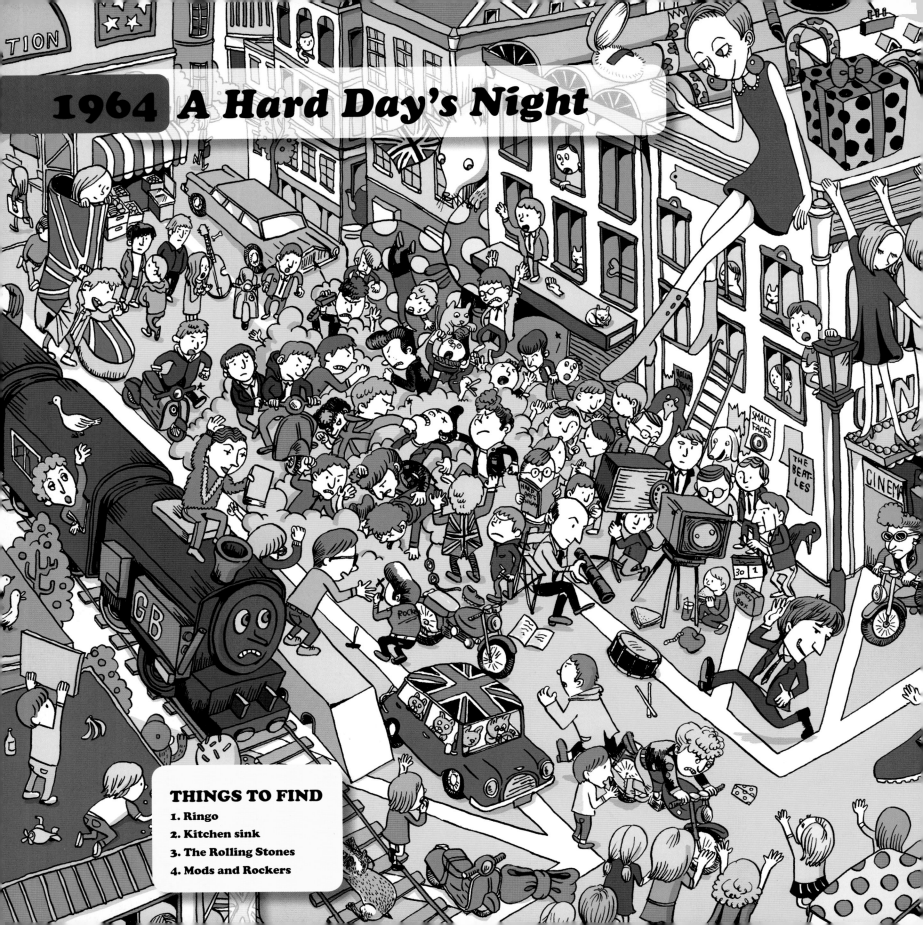

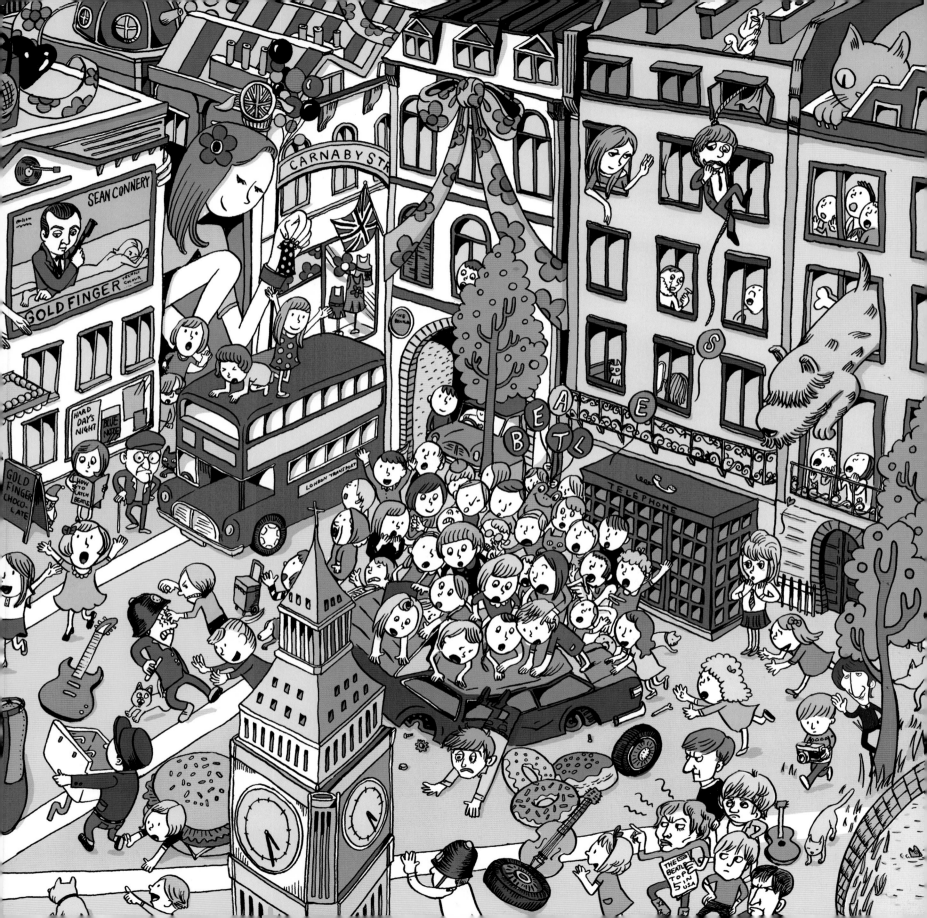

A Hard Day's Night

On 2 March, the Beatles returned to the UK to begin shooting their first feature film, *A Hard Day's Night*. Initially, United Artists undertook the film just for the soundtrack money, but an excellent creative team was assembled.

The cinematographer was Gilbert Taylor, who had recently finished shooting Stanley Kubrick's *Dr Strangelove*, also released in 1964. Liverpudlian Alun Owen's screenplay was later nominated for an Academy Award.

Director Richard Lester's innovative, sometimes surreal direction was replete with quick cuts, handheld moving camera shots and images edited to the songs' beats. It was enormously influential in both film and television and established the template for music videos. A standout sequence was the euphoric 'Can't Buy Me Love' set piece, which drew on the group's iconic 'jumping' photos by Dezo Hoffmann. The exuberance of the Fab Four running through the field, briefly escaping their grinding schedule, won over even the most skeptical highbrow movie critics, garnering comparisons to the Marx Brothers. In 2005, *Time* named the film one of the top 100 movies of all time.

The plot happens over two days during which the band comes under threat when Paul's jealous grandpa convinces Ringo to go AWOL. Ringo received glowing reviews that ensured the Beatles' next film would be centred on him.

Still, Richard Lester suspected John might be the true actor of the group with his mixture of confidence and fearlessness in being silly, such as the moment where he flutters his eyelashes at an overbearing old man and taunts him with the words, 'Give us a kiss.'

George gave an equally assured performance. The scene where he tears a pompous marketing executive to shreds was a precursor both to his musical sermons (such as the song 'Think for Yourself') and the 1960s counterculture's rejection of consumerism. Screenwriter Owen wrote a sequence in which Paul flirts with an actress, but it ended up on the cutting room floor and sadly the negative was not preserved. The scene is one of the few examples of stilted dialogue in Owen's script, so perhaps Paul wasn't entirely to blame.

The album was their first to contain all original compositions and the only one in which all the songs are by Lennon–McCartney. In fact, it is almost a John solo album, as nine of the thirteen tracks are his, from the joyous 'I Should Have Known Better', to the vulnerable 'If I Fell' and 'I'll Cry Instead'. With 'And I Love Her', Paul took what he learned from covering show tunes and fashioned his own standard, aided mightily by the acoustic guitar riff George came up with. It is one of the few Beatles LPs on which Ringo does not sing lead on one track. But the title was his. After a gruelling day's work, Ringo said, 'It's been a hard day's – ', then noticed it was dark outside and added, 'night!' Director Lester seized on the phrase and John wrote the song in one evening.

Above: John Lennon with Ringo.

DID YOU FIND?

1. Ringo
In the mostly wordless scenes in which he wandered off from the group, befriended a street kid and got into trouble, the lack of dialogue was due to the fact that Ringo had shown up to work so hungover that he couldn't handle any lines.

2. Kitchen Sink
The kitchen-sink realism movement of the late 1950s and early '60s (which included films such as *Saturday Night and Sunday Morning* and plays such as *Look Back in Anger*) celebrated working class angry young men. It added to the Beatles' appeal that they had come from the Liverpudlian hinterlands.

3. The Rolling Stones
The Stones' manager Andrew Loog Oldham had originally been a publicist for the Beatles and he brilliantly fashioned his London blues band into the anti-Beatles – the group parents loved to hate.

4. Mods and Rockers
Two young male British subcultures – the 1950s-styled Rockers and the sharp-dressing Mods – famously rumbled into seaside resort towns in the south of England, where they clashed violently in May 1964. The Beatles had once been rockers but, their image had changed, so in the movie when the reporter asks Ringo if he's a Mod or a Rocker, he replies that he's a Mocker.

BONUS

5. *A Cellarful of Noise*
Brian published his memoir in 1964, ghostwritten by Beatle publicist Derek Taylor.

6. Richard Lester
The Beatles were sold on Lester because comedian Peter Sellars picked him to adapt *The Goon Show* radio program (one of the boys' favourites) for television.

7. Pattie Boyd
George first met the model who would be his wife when she had a brief role as a schoolgirl in *A Hard Day's Night*. He immediately asked her to marry him (jokingly), but was nervous enough around her that he asked manager Brian to accompany them on their first date to help make conversation.

8. Jane Asher
From 1963 to 1966 Paul lived in the garret atop a six-floor town house owned by the parents of his girlfriend Jane Asher. Her brother was Peter Asher of the group Peter and Gordon, who relied on Paul for many of their early hits.

9. Norm, Shake and the TV director
Beatles road manager Neil Aspinall, roadie Mal Evans and Brian Epstein were represented in *A Hard Day's Night* as Norm, Shake and – perhaps – the nervous television director.

1964 Beatlemania

THE BEATLES

VS

THE FOUR SEASONS

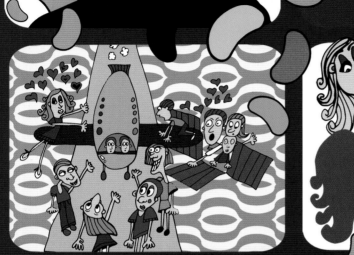

twist and shout

THE BEATLES

FEATURING 'SHE LOVES YOU'

RINGO

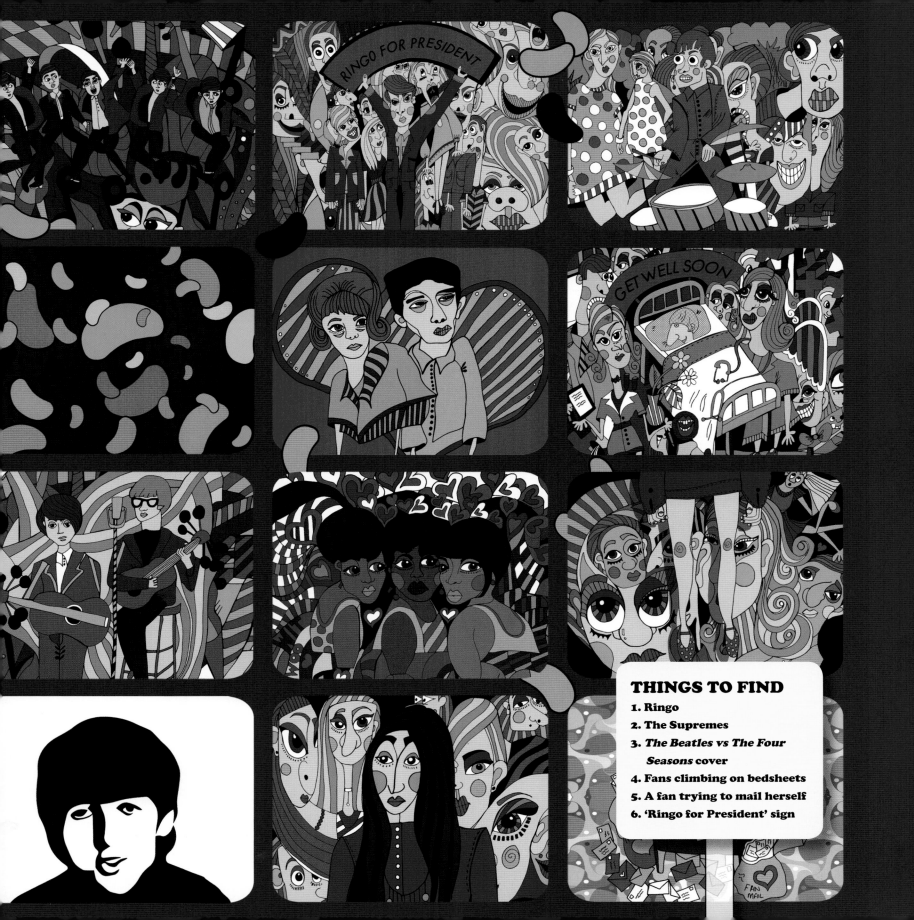

THINGS TO FIND
1. Ringo
2. The Supremes
3. *The Beatles vs The Four Seasons* cover
4. Fans climbing on bedsheets
5. A fan trying to mail herself
6. 'Ringo for President' sign

Beatlemania

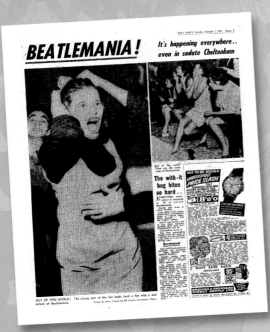

BEATLEMANIA! It's happening everywhere.. even in sedate Cheltenham

At first Beatlemania had a bit of help from the press. When the band appeared on *Sunday Night at the London Palladium* in 1963, the *Daily Mirror* wrote that police fought back 1,000 teenagers – but the Beatles' photographer Dezo Hoffmann later put the count at about eight. However, by the time Beatlemania kicked into high gear publicists didn't need to fudge the numbers.

Police barricades had to be set up at hotels to keep the throngs at bay. Some fans even tried to climb the sides of the buildings. The hotels were besieged with fan mail, more than one fan attempting to mail themselves. Sheets and doorknobs were stolen as mementos.

The most adrenaline-packed part of the group's day was the escape after the concert, sometimes in delivery trucks, armoured cars or ambulances. In Texas fans stormed the airport runway and climbed on the wings. On 4 April, 1964, the Beatles' singles held eleven spots on the US pop charts – to date they are the only group to hold down the top 5 spots simultaneously.

Beyond the music, their hair was giving youth a new identity, one that undermined postwar conformity. John's first book, *In His Own Write*, came out – featuring the subversive wordplay that would later flower in songs like 'I Am The Walrus'.

The 1964 track 'I Feel Fine' marked possibly the first time guitar feedback was intentionally used on record. The Who and the Kinks

had experimented with it in concert, but not in the studio. The Beatles strove to constantly surprise their audience by doing the opposite of what was expected. The cover for *A Hard Day's Night* featured them making funny faces, mirroring the happy spirits within. Thus *Beatles For Sale*'s autumnal cover revealed four weary if not sombre faces and the set opened with John's threatening 'No Reply' followed by the self-loathing of 'I'm a Loser'.

Still, John included the ebullient 'Eight Days A Week', a No. 1 single in the US, and his regular go-for-broke cover, this time Chuck Berry's 'Rock and Roll Music', knocked out in one take (not too hard since he played it in nearly every set of the Beatles' live career).

Paul's 'I'll Follow the Sun' showed his mastery of wrapping a bitter sentiment inside a deceptively pretty melody. Ringo kept the beat by slapping his knees. 'Every Little Thing' was one of the few instances where John sang a song primarily authored by Paul. It listed the qualities of Paul's ideal woman – one who did every little thing for

Above: British newspaper report on Beatlemania.

him. Unfortunately Jane Asher couldn't do that because she was determined to pursue her acting career. After Paul found a woman who truly would accompany him here, there and everywhere – Linda

Eastman – angst such as in the pained gem 'What You're Doing' largely disappeared from his work in the '70s.

DID YOU FIND?

1. Ringo
On 3 June, 1964, the Beatles' backbreaking schedule caught up with Ringo and he had to be hospitalised for tonsillitis. Ringo admitted later he was very nervous they'd permanently pull a Pete Best on him, but he rejoined his brothers on 15 June.

2. The Supremes
They were in actuality the Beatles' biggest rivals on the US charts, with 12 No. 1 singles. Elvis had 17 and the Beatles had 20.

3. *The Beatles vs the Four Seasons* album
The Beatles' first American label Vee Jay also handled Frankie Valli and the Four Seasons, so they cashed in with this double album featuring Beatles songs on one disc and the Four Seasons on the other – 'The International Battle of the Century!'

4. Fans climbing on bedsheets

5. A fan trying to mail herself

6. 'Ringo for President' sign
Several artists recorded this song. When a reporter asked, 'Ringo, would you nominate the others as part of your cabinet?' he replied, 'Well, I'd have to … wouldn't I?' George: 'I could be the door'.

BONUS

7. Jelly babies
George made the mistake of saying he liked them and concerts became a hailstorm of these eye-endangering sweets.

8. Peter and Gordon
Paul wrote 'A World Without Love' at age 16, but whenever he would sing the first line to John – 'Please lock me away' – John would say, 'Yes, okay', and the song would progress no further. Paul later gave the track to Jane Asher's brother Peter, of Peter and Gordon.

9. The Dave Clark Five
The second most popular band of the British invasion parted their hair and cast aspersions on the Beatles' 'strange' haircut. Still, they imitated the famous photo of the Beatles jumping by Dezo Hoffmann, as did everyone from the Beau Brummels to Wilson Pickett.

10. Cher
Cher's first single was 'Ringo I Love You'. It flopped because, she said later, her deep voice led many to believe she was a man.

11. Carole King and Gerry Goffin
When the Beatles came to the US they wanted to meet this songwriting couple, writers of classics like 'Will You Still Love Me Tomorrow', 'One Fine Day' and 'Up on the Roof'. They wouldn't actually meet until 1965.

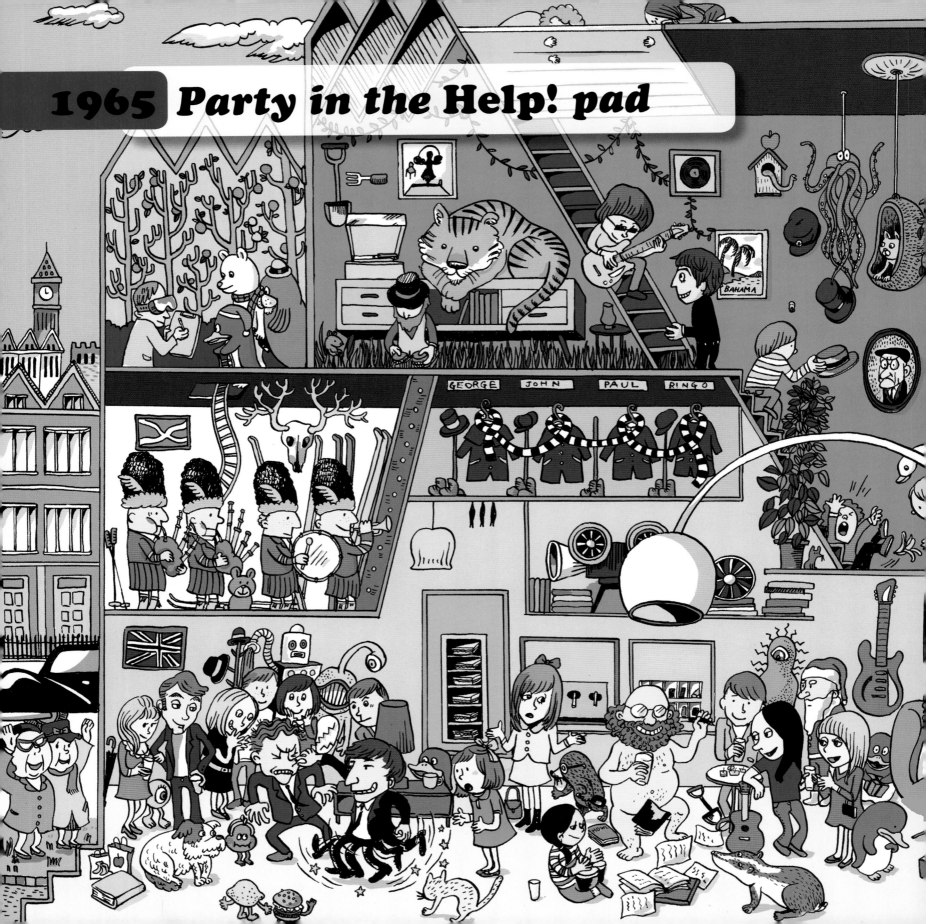

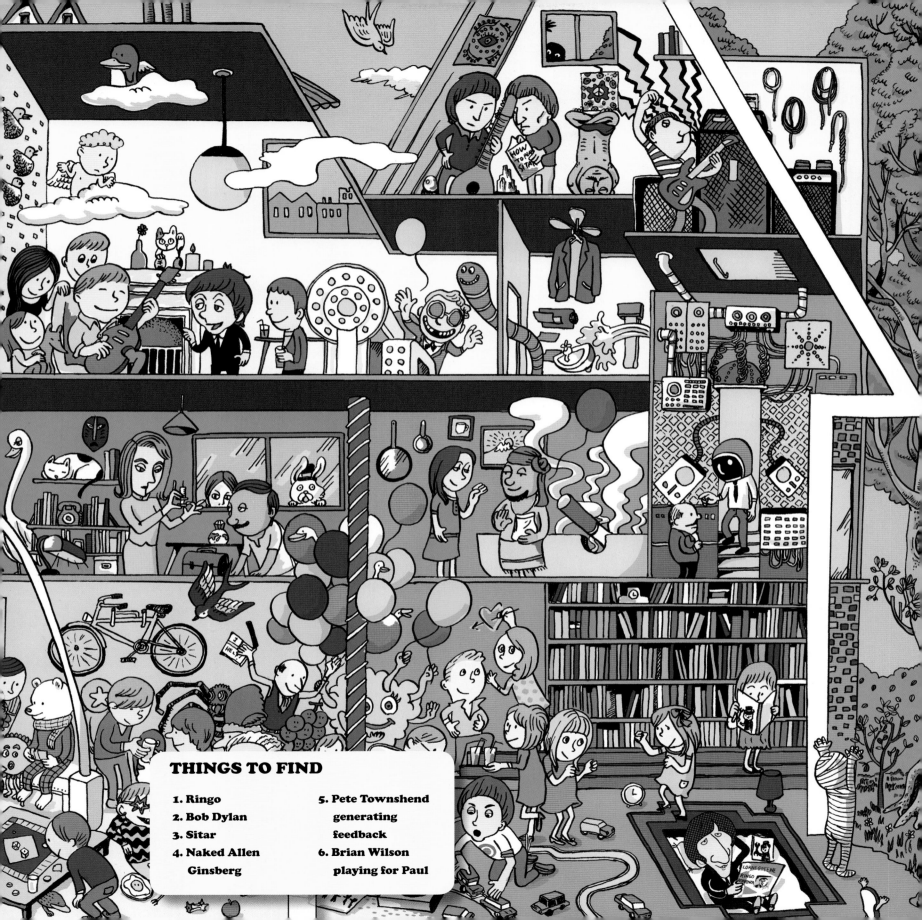

THINGS TO FIND

1. Ringo
2. Bob Dylan
3. Sitar
4. Naked Allen Ginsberg
5. Pete Townshend generating feedback
6. Brian Wilson playing for Paul

Party in the Help! pad

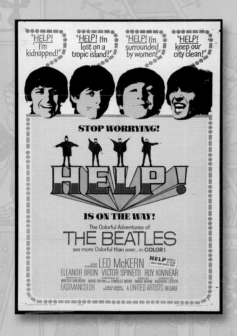

On 23 February, 1965, the Beatles began shooting their second movie, *Help!* In the film, the sacrificial ring of a bloodthirsty cult has ended up on Ringo's finger and the sect is now determined to kill him. Most of the screen time features the boys trying to escape the villains in what was envisioned as a parody of the James Bond series.

This time around, director Richard Lester focused more on the supporting actors and his own innovative pop art style (now in colour). The resulting film is not as much of a classic as *A Hard Day's Night* but was still very popular with the younger fans. The cartoony image of the band would be further exploited in both the Beatles' own Saturday morning cartoon series (1965–1969) and the television show *The Monkees* (1966–1968).

For the first single of the soundtrack, John took the ringing twelve-string arpeggio George had played at the fade-out of 'A Hard Day's Night' and slowed it down for the haunting jangle of 'Ticket to Ride'. Ringo's off-kilter, rolling drums were a precursor to the rave-rock of 'Tomorrow Never Knows' and capped a massive sound that John would later proudly deem 'pretty f---in' heavy for then'.

Originally the movie had been entitled *Eight Arms to Hold You*, a reference to both the total number of the Beatles' arms, and the arms of the Hindu goddess Kali. But Lester eventually came up with the less creepy *Help!* and John banged out the theme in one night, almost a year to the day he had done the same thing for the first film. John didn't think much of his composition at the time, but later he would realise it was an honest cry for emotional support.

On the surface, 1965 seemed a duplicate of 1964 for the Beatles – another two albums, another movie, more huge tours, and a second book of short humour pieces by John. But as universal success became commonplace to him, it no longer medicated John from the damage of his troubled childhood and, could itself be overwhelming.

And the song mirrored the insecurity of the Baby Boomers themselves. As shifts in attitudes to sexual and race relations (and war and drugs) caused conflict and confrontation, a heightened sense of mass anxiety was only natural. Neurosis became a pop culture common denominator, whether in Charlie Brown, Woody Allen or the outsider heroes of Marvel Comics like Spider-Man, the Thing and the X-Men.

Above: The poster for the Beatles' 1965 movie Help!

DID YOU FIND?

1. Ringo
He's lounging in John's bed, a sunken pit in the floor with steps leading down and a mini-bookcase – one of the more interesting beds in cinema.

2. Bob Dylan
Dylan met the band in New York in August 1964, and their friendship encouraged the folk singer to fuse his increasingly surreal poetry with rock and roll. In turn he inspired John to write deeper and more introspective songs. Dylan felt Lennon borrowed too freely with 'Norwegian Wood' so he spoofed it with '4th Time Around', after which John's overt Dylan homages stopped.

3. Sitar
Though *Help!* was politically incorrect in its portrayal of Hindus as human sacrificing buffoons (played by white actors, no less), the movie gave George his first exposure to the Indian instruments and philosophy that he would later promote to millions of listeners.

4. Naked Allen Ginsberg
In 1965, Ginsberg, the author of *Howl* (1955) wrote the poem 'Portland Coliseum' about a Beatles concert and originated the concept of Flower Power for an anti-Vietnam war rally in Berkeley.

5. Pete Townshend generating feedback
After the Beatles witnessed the Who and the Kinks use feedback in their stage performances, John used it for the intro of their single 'I Feel Fine'.

6. Brian Wilson playing for Paul
Like Paul, the Beach Boys' leader was a brilliant writer, singer, arranger and bassist. Wilson's determination to top *Rubber Soul* would result in his masterpiece *Pet Sounds*, which in turn prodded the Beatles to the heights of *Sgt. Pepper*.

BONUS

7. Greek fisherman's cap
Though the hat was often called the 'John Lennon hat', Dylan wore one on his self-titled first album in 1962.

8. 12-string Rickenbacker
When lead singer of the Byrds Roger McGuinn saw George's twelve-string in *A Hard Day's Night*, he was inspired to get his own. McGuinn's jangling intro to the Byrds' cover of Dylan's 'Mr. Tambourine Man' kicked off the folk rock boom.

9. Lorne Greene's single 'Ringo'
The *Bonanza* star's song was about the gunfighter Johnny Ringo, but it shot to number one in the United States thanks to Ringo-mania.

10. Keith Moon
The Who drummer was one of Ringo's best friends. His anarchy on the skins would goad Ringo to match him in his wildest moment, 1966's 'Rain'.

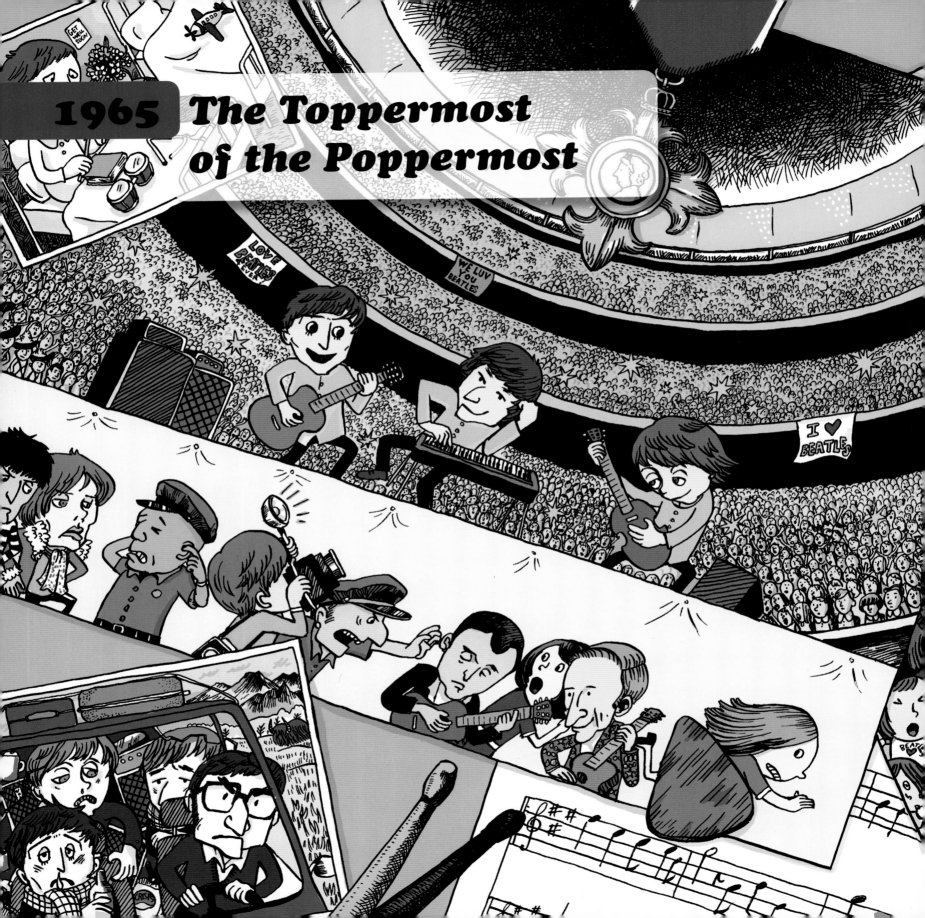

The Toppermost of the Poppermost

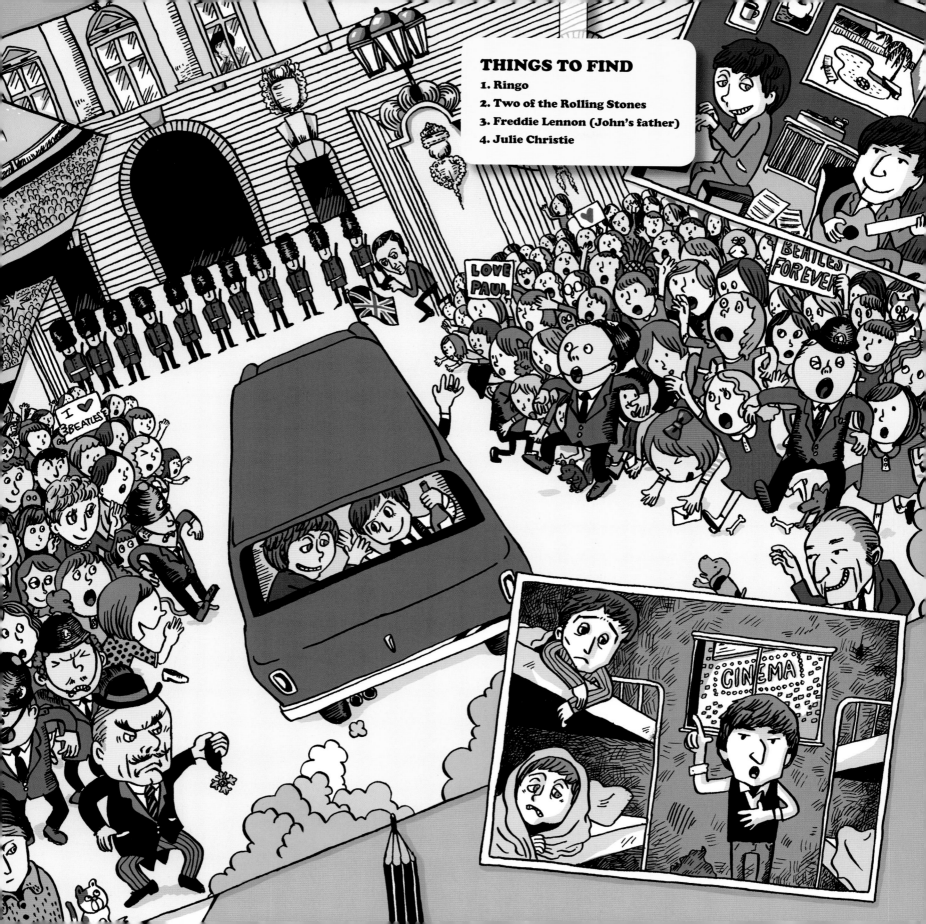

THINGS TO FIND
1. Ringo
2. Two of the Rolling Stones
3. Freddie Lennon (John's father)
4. Julie Christie

The Toppermost of the Poppermost

Above: Shea Stadium, New York.

'When the Beatles were depressed, thinking, the group is going nowhere, John later recalled, I'd say, "Where are we going, fellas?" They'd go, "To the top, Johnny!" And I'd say, "Where's that, fellas?" and they'd say, "To the toppermost of the poppermost!" and I'd say, "Right!" Then we'd all cheer up.'

In 1965 the 'toppermost' was playing the first concert in a baseball stadium (Shea Stadium in New York) to 55,000 fans on 15 August and becoming Members of the Order of the British Empire on 26 October. The honour from the Queen was in recognition of the huge revenues they generated when they opened the US market to British pop music and fashion.

The year also saw the release of Paul's most successful song. The melody for 'Yesterday' came to Paul in a dream in early '64, but he was afraid he had subconsciously plagiarised it. He played it for associates for a year to see if anyone recognised it, while trying to come up with better lyrics than the placeholders, 'Scrambled eggs/ oh baby I love your legs'. Decades after he settled on the final words, he would concede perhaps they were subconsciously inspired by his mother's death from breast cancer when he was 15. When he had learned of her death, he had asked aloud, 'What will we do without her money?' and later felt ashamed, which many have speculated inspired the 'I said something wrong' line.

None of the other Beatles could think of anything to add to the track, so Paul hesitantly acquiesced to producer George Martin's desire to accompany him with a string quartet. Paul didn't want to look like he was trying to be a solo artist, so it wasn't released as a single in the United Kingdom. In the United States, though, it held the top spot for four weeks. It became the most covered song of the decade, its aching desolation further propelling the group away from its teenybop image. Its success also began the shift in dominance between himself and John in the group.

Of their first ten UK singles, only two had been primarily McCartney compositions (five had been Lennon's). But now Paul hit his groove as the writer of universal hit singles. In the second half of the Beatles' career, the only other A-sides Lennon would have were 'All You Need Is Love' and 'The Ballad of John and Yoko', with 'Strawberry Fields Forever' being a double-A with 'Penny Lane'.

DID YOU FIND?

1. Ringo

2. Two of the Rolling Stones
Although the press liked to pitch them against each other, the two bands were good friends – and some of the Stones were backstage for the Shea Stadium gig.

3. Freddie Lennon
John's father disappeared on him when John was five, but returned after John made it, looking a lot like his son, if his son had lived sixty years with one foot in the gutter and lost his teeth. Freddie even released the single 'That's My Life (My Love and My Home)' on 31 December, 1965.

4. Julie Christie
The British actress dominated the 1966 Academy Awards, winning Best Actress for *Darling* while the epic she starred in with Omar Sharif, *Dr Zhivago*, won five Oscars and was nominated for Best Picture.

BONUS

5. Carl Perkins
Perkins was a favourite of the Beatles. Ringo made it to No. 17 in the US and No. 6 in Canada with his cover of Perkins' 'Matchbox', and followed up with Perkins' 'Honey Don't' on *Beatles For Sale*.

6. Buck Owens
Owens was the architect of the Bakersfield country sound, the earthier alternative to slick Nashville country pop. Ringo covered his movie-themed single 'Act Naturally' for the *Help!* album, which peaked at No. 47 in the US as the B-side to 'Yesterday'.

7. James Bond
007 made his cinematic debut the same year the Beatles premiered on record and, in 1973, George Martin was hired to create the soundtrack to *Live and Let Die*, enlisting Paul to write the high-voltage theme song.

8. Petula Clark
She hit No. 1 in the US and No. 2 in the UK with her anthem 'Downtown' (1964). Its follow up, the ode to nightlife 'There's a Place' (1965), namechecked Brian Epstein's memoir *A Cellarful of Noise*.

9. Paul Revere and the Raiders
In the wake of the British Invasion of the US charts, many American bands adopted English-sounding names and costumes. Paul Revere took the opposite tack, dressing in Revolutionary War uniforms.

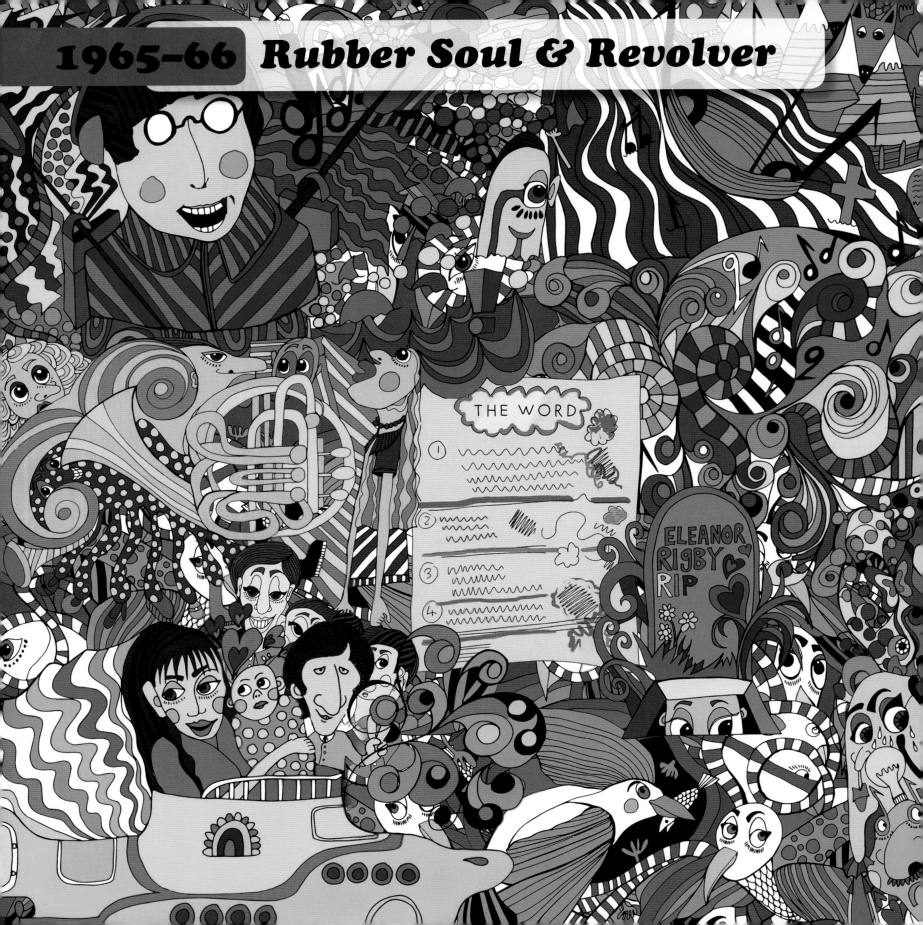

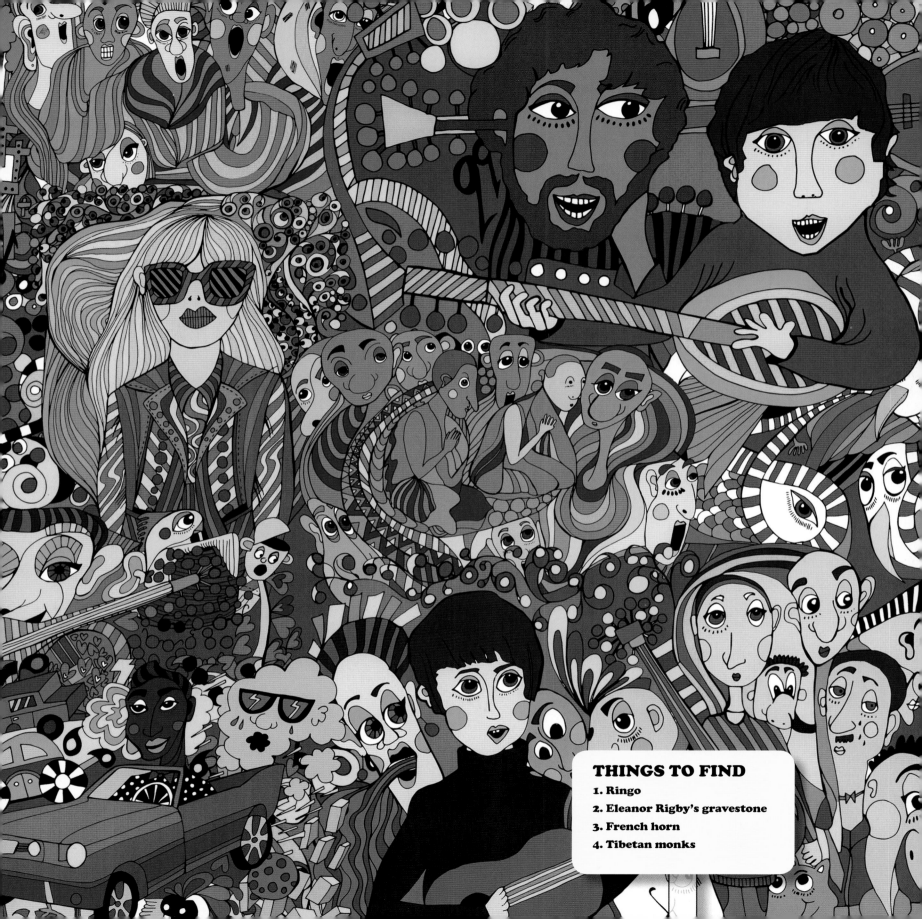

THINGS TO FIND

1. Ringo
2. Eleanor Rigby's gravestone
3. French horn
4. Tibetan monks

Rubber Soul & Revolver

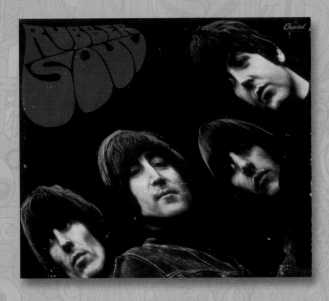

With the Christmas deadline for the release of *Rubber Soul* looming, John found himself with a horrible case of writer's block. Finally he gave up trying to write. Then suddenly 'Nowhere Man' came out in a flood.

In the song John gently berated himself for not using the massive power at his command, the flipside to 'Help!' The song also included a touching ode to his partnership with Paul, as he sings to himself not to worry, soon his partner will be lending a hand – Paul was coming over in the morning to work on the songs.

Rubber Soul brought a new adult sophistication to their writing in songs like 'Norwegian Wood' and 'In My Life', though for Ringo they unearthed a song John had composed back when he was in the Quarrymen, 'What Goes On'. Ringo added (by his estimation) five words, so they gave him a co-writing credit.

Rubber Soul was released 3 December, the same day as the single 'We Can Work It Out'/'Day Tripper'. Featuring verses by Paul and bridge by John, 'We Can Work It Out' was the last of the Beatles' string of six US number one singles in a row, a record they would hold until the Bee Gees tied them in 1979 and Whitney Houston topped them with seven in 1988.

Eight months later, *Revolver* was released. Though for decades *Sgt. Pepper* was considered their best album, many critics today maintain *Revolver* to be the band's masterpiece. Certainly it is the most balanced between different Beatles, with Paul's baroque pop and John's acid rock each getting five tracks, George three and Ringo one with the children's sing-along Paul wrote for him, 'Yellow Submarine'. Ringo's song made it to No. 1 in the UK and No. 2 in the US, his biggest smash yet.

Paul began looking to earlier musical eras and continued to maintain their commercial accessibility with romantic ballads while John pushed rock into the future, inspiring engineers like Geoff Emerick and Ken Townsend to develop new technologies like automatic double tracking (ADT) to achieve John's psychedelic visions.

John became fascinated with the possibility of playing music backwards one night when he accidentally put his demo for 'Rain' on his home tape machine the wrong way. He liked the effect so much, he added it to the ending of the song (which had been inspired by a massive storm the group encountered in Melbourne, Australia).

In the '70s and '80s conservative parents began to fear that

Above: The Rubber Soul *album artwork.*

rockers were imparting subversive messages via backwards masking in their children's music – it all began here. Defiantly uncommercial, it still made it to No. 23 as the B-side to Paul's 'Paperback Writer'. Ringo felt his drumming on 'Rain' was the best in his career. 'I'm Only Sleeping' also used backwards guitar; Harrison figured out the notes, played them in reverse order, then had the engineers run the guitar backwards for the instrumental.

DID YOU FIND?

1. Ringo

2. Eleanor Rigby's gravestone
When Paul's aunt challenged him to write about a subject other than love he came up with this lonely tale. This song about death followed George's rant about taxes on *Revolver*. After this the group would cease writing straightforward love songs until 'Hey Jude'. Ironically there was an Eleanor Rigby buried at the church where he first saw John play with the Quarrymen.

3. French horn
'For No One' was one of the most disconsolate songs inspired by Paul's fights with Jane Asher, thanks in no small part to the solo played by renowned horn player Alan Civil.

4. Tibetan monks
John's lyrics for 'Tomorrow Never Knows' were inspired by a book called *The Psychedelic Experience: A Manual Based on the Tibetan Book of the Dead.*

BONUS

5. Paul writing 'Michelle'
Composed first as a pretentious French parody, 'Michelle' won the Grammy for Song of the Year in 1967.

6. Lyric sheet for 'The Word'
After John and Paul wrote the track, they embellished the lyric sheet with coloured crayons. Avant-garde composer John Cage collected music scores, and his associate Yoko Ono asked John for one. He gave her 'The Word'.

7. Zak Starkey
Ringo married Maureen Cox on 11 February, 1965, and Zak was born 13 September. He would grow up to play drums in the Who. Their former drummer Keith Moon had been one of Ringo's best friends until his untimely death in 1978.

8. Wilson Pickett
Memphis' Stax Records was the grittier rival to Motown's slick Northern soul. With 'Drive My Car' the Beatles attempted to emulate the deep bass of Stax artists like Pickett and Otis Redding, and the title *Rubber Soul* itself was based on a black singer's dismissal of Mick Jagger as 'plastic soul'.

9. John Sebastian's glasses
John Lennon had been too vain to wear specs in public before, but wire frame-wearing John Sebastian had recently led the Lovin' Spoonful to the top of the charts with a string of hit singles the Beatles admired.

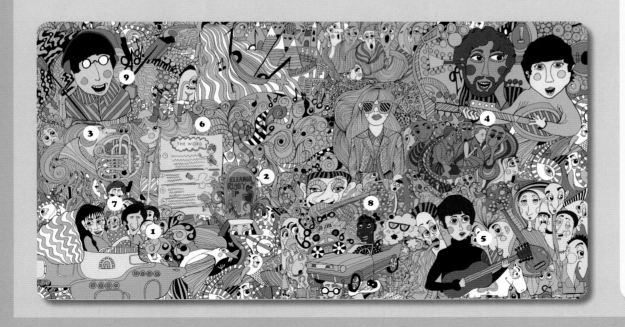

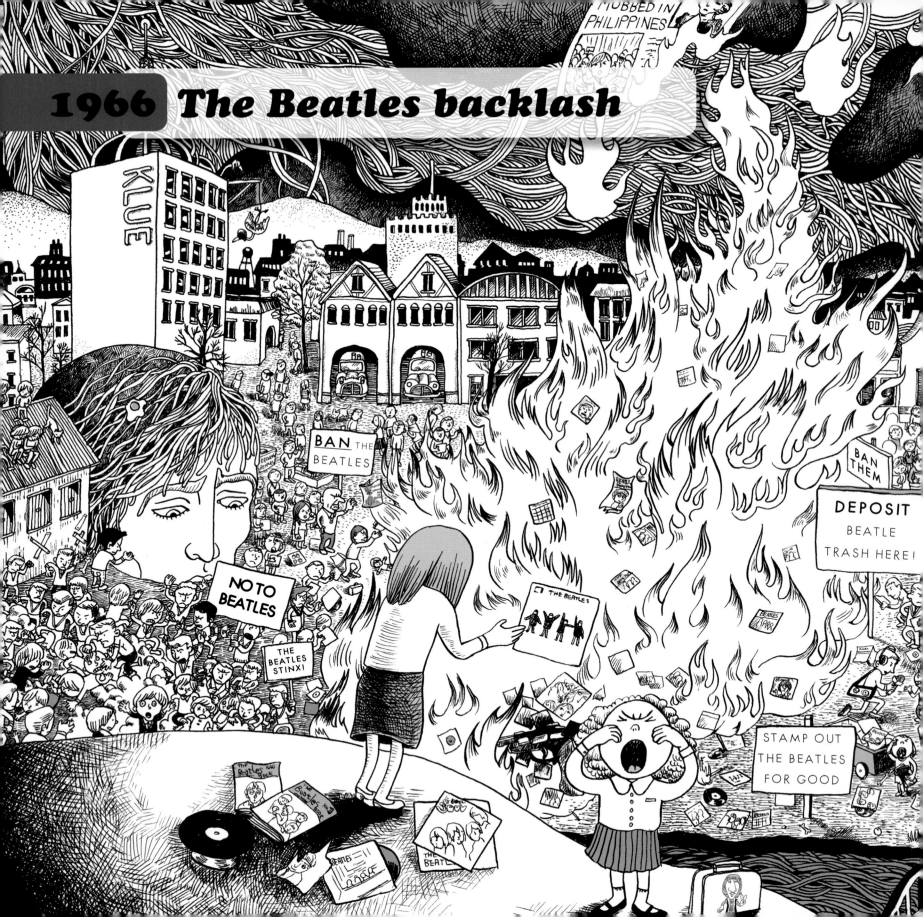

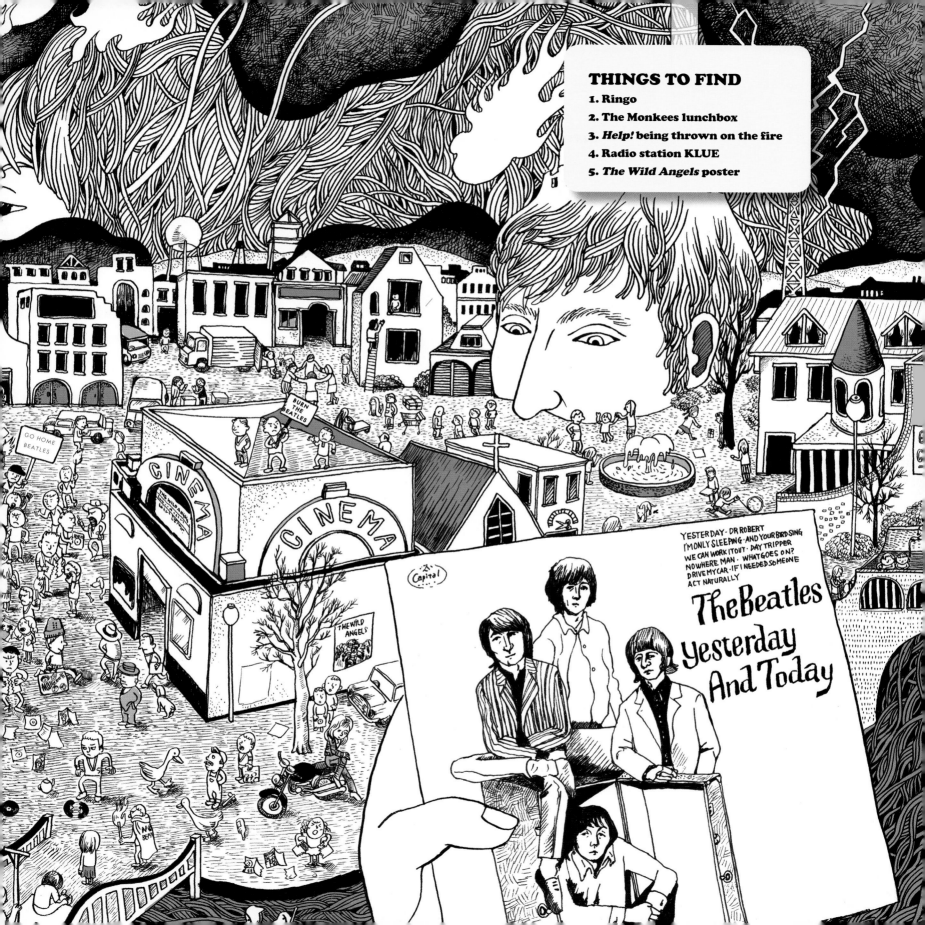

THINGS TO FIND
1. Ringo
2. The Monkees lunchbox
3. *Help!* being thrown on the fire
4. Radio station KLUE
5. *The Wild Angels* poster

The Beatles backlash

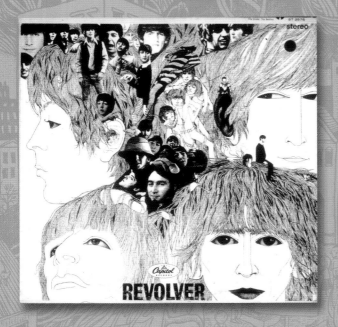

Having been the beneficiary of so much global goodwill for the last three years, perhaps the Beatles were due for some serious blowback. It came just a few months before their new album *Revolver* was to be released, when John spoke blithely with his friend (and paramour) journalist Maureen Cleave for the London Evening Standard in March 1966.

'Christianity will go', he said. 'It will vanish and shrink. I needn't argue about that. I'm right and will be proved right. We're more popular than Jesus now. I don't know which will go first – Christianity or rock and roll.'

The quote betrayed the bubble he lived in – believing his band to be more popular than a global religion with over a billion adherents – but more surprising was how angrily American fans reacted when the lines were printed out of context, in the teenage magazine *Datebook*, in August. Radio stations banned the playing of Beatle records and burned them on bonfires. The South, wracked by the bloody turmoil of the civil rights movement, was also filled with xenophobia for girly-haired bands that dared criticise the Vietnam War, as John increasingly did. Many adults seriously believed that Western civilisation had begun its decline with the advent of the Beatles.

In Chicago on 12 August, a shaken John tried to appease the press

with, 'I'm not saying that we're better or greater, or comparing us with Jesus Christ as a person or God as a thing or whatever it is', but still ended up sounding vaguely irreverent. When firecrackers went off during concerts, the group feared that the Ku Klux Klan was making good on their death threats. Mark David Chapman was enraged by John's comments, and would retaliate fourteen years later.

By the end of the American tour they were all ready to quit touring. 'Can I please go home to my mummy now, please can I?' asked Ringo after the group was stuck for hours in LA's Dodger Stadium post-show, when five getaway vehicles – a backwards-speeding armoured car, three limos and an ambulance – were all thwarted by marauding fans. The following day's concert on 29 August in San Francisco's Candlestick Park was their last, except for their rooftop set in 1969 for the film *Let It Be*.

Above: The Revolver *album artwork.*

DID YOU FIND?

1. Ringo
The Beatles cartoon show caricatured him as a dim-witted clown with a particularly dopey laugh. *Yellow Submarine* would provide a better depiction.

2. The Monkees lunchbox
The pre-Fab Four supplanted Herman's Hermits as the band that filled the teenybopper void the Beatles had outgrown.

3. *Help!* being thrown on the fire

4. Radio station KLUE
This station in Longview, Texas famously organised a bonfire for Beatles albums. Beatle legend has it that the next day a lightning bolt knocked out its broadcast tower.

5. *The Wild Angels* poster
The star of *The Wild Angels* (1966) and *Easy Rider* (1969) freaked the Beatles out during a party with The Byrds when Peter Fonda recounted his near-death experience at 11 from a self-inflicted gunshot wound. John recounted the bad trip in 'She Said She Said', changing Fonda to a woman.

BONUS

6. *A Spaniard in the Works*
John's second book was published on 24 June, 1965. Soon Dylan's example would show him that he didn't need to keep his satirical flights of fancy separate from his pop songs – he could pour all his ideas, no matter how strange, into his music.

7. *Beatles Book Monthly*
The Beatles' official fan magazine ran from August 1963 to December 1969 for 77 issues, and would return from 1976 to 2003. Its circulation reached 330,000 a month by the end of 1963.

8. 'Communism, Hypnotism and the Beatles'
Evangelist David A Noebel theorised in this 1965 pamphlet and the 1966 sequel *Rhythm, Riots and Revolution* that the Beatles were agents of the Soviet Union out to brainwash teens into accepting Communism. No doubt John's 1966 discovery of backwards vocals and Paul's 1968 spoof 'Back in the USSR'. fuelled Noebel's paranoia.

9. Newspaper report of Beatles being mobbed by crowds in the Philippines
On their 1966 Far East tour, the Fabs got death threats in Japan from right-wing nationalists. Then in the Philippines, when they blew off a luncheon given by First Lady Imelda Marcos, the crowd turned against them: the Beatles' entourage fled to the airport, many (including Brian) being kicked and punched.

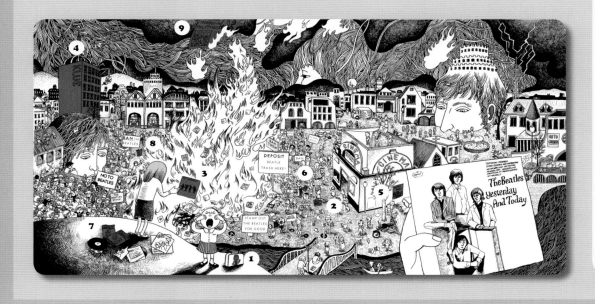

Sgt. Pepper's Lonely Hearts Club Band

After the Beatles finished touring, the group took their first extended break from each other in many years. John accepted a role in Richard Lester's surreal black comedy *How I Won the War* (released 1967). Isolated on location in Spain, John recalled the Liverpool orphanage Strawberry Field; he and his friends used to play on its grounds.

In his youth John often felt one step away from an orphan himself, and the loneliness echoes in the demo he recorded for the song, later included on *Anthology 2*.

Back in the studio in November, John was ready to follow Paul into baroque pop with the help of producer George Martin. Martin was never more the fifth Beatle than in the orchestral epics of 1967, directing brass and string ensembles for the group just as he had often played piano with them on earlier Beatle tracks. In 'Strawberry Fields Forever', his trumpets and cellos change John's mood from fragile and yearning to detached, almost angry – the Nowhere Man overcoming childhood abandonment through cosmic megalomania. With voice slowed through studio technology, and a new look of wire-frame glasses and moustache, the boyish John of Beatlemania was gone for good.

The balance of mood that accounted for the Beatles' success was never more apparent than in Paul's response to 'Fields'. He, too, looked back on his youth for inspiration, but instead of the abyss he found the blue suburban skies of 'Penny Lane' and brought in ever more instruments to express his ebullience – flutes, piccolos, trumpets, flugelhorns, oboes, cor anglais and double bass.

As an exercise to free his mind and get out of the Beatle mould, Paul decided it would be good to pretend to be a different band for the new album. He was flying back from a safari in Nairobi with roadie Mal when they looked at the salt and pepper packets on the plane marked S and P, and the name Sgt. Pepper came to mind. Soon the moniker expanded in homage to the new San Francisco rock groups with unwieldy names like Big Brother and the Holding Company.

The Lonely Hearts Club Band's jackets were discovered when Paul and album cover designer Peter Blake passed a Portobello Road boutique called I Was Lord Kitchener's Valet, which sold antique military uniforms. The cover would top

THINGS TO FIND
1. Ringo
2. Marlene Dietrich
3. Sonny Liston
4. Oliver Hardy

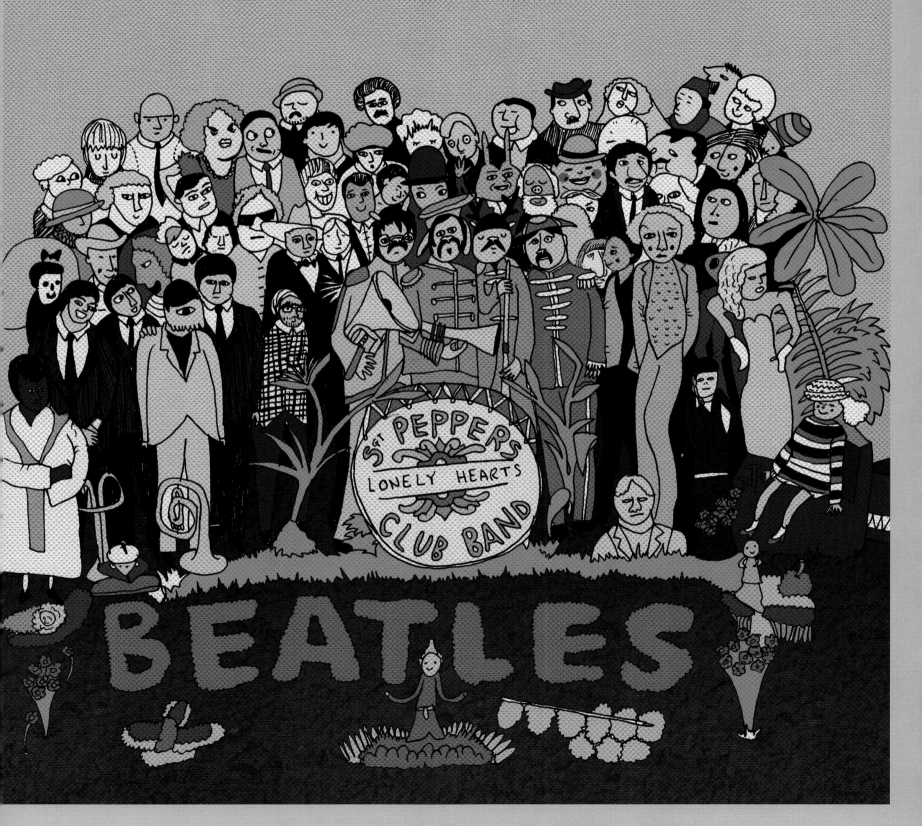

Sgt. Pepper's Lonely Hearts Club Band

Revolver in pop-art sensory overload, with over 70 figures picked (mostly) by the Beatles, ranging from intellectuals to singers, writers, actors – and Stu Sutcliffe. For the first time in pop, the lyrics were printed on the back cover.

John's 'Lucy in the Sky with Diamonds' encapsulated the bliss of the psychedelic dream, while 'Good Morning, Good Morning' captured the hangover afterwards. And as they pushed on into the future, Paul also delved further into the past, unearthing a music hall-flavoured tune he wrote before his partnership with John, 'When I'm 64'. For Ringo, John and Paul composed his most universal Beatle anthem, 'With a Little Help from My Friends'.

But while the rest of the album captured the euphoria of the Summer of Love, its final track was inspired by the first death in the Beatles' circle since Stu. Guinness heir Tara Browne was only 21 when he died in the car crash memorialised in the first verse of 'A Day in the Life'. It rose to an apocalyptic crescendo with a 40-piece orchestra and John's muezzin-like wailing before a final doomsday chord

hammered by John, Paul, Ringo, Mal and George Martin simultaneously on three pianos and one harmonium. The song was hailed as an artistic breakthrough for the band to compare to TS Eliot's 'The Waste Land'. In a scant four and a half years the Beatles had transformed rock music into the premiere art form of its time.

For decades *Sgt. Pepper* has stood as the de facto best album of all time, though in truth John's influence is missed as Paul outnumbers him in songs on the disc seven to four. George Martin would later regret that British custom dictated they not include the single from the sessions, 'Penny Lane'/'Strawberry Fields Forever'. If those two songs had been included, its status as the greatest album would be much harder to dispute.

Top: The Beatles at the launch of Sgt. Pepper; *below right: Peter Blake.*

DID YOU FIND?

1. Ringo

2. Marlene Dietrich
World-famous chantreuse and movie idol, who rose to fame in Berlin in the 1920s and who was still a sex symbol into her sixties (including having an affair with JFK).

3. Sonny Liston
World Heavyweight Champion boxer who sensationally won the title from Floyd Patterson in 1962, but then lost it to Cassius Clay (the future Muhammad Ali) in 1964.

4. Oliver Hardy
American comedy star of the silent era and early talkies, who made more than a hundred comedies alongside his partner, the British Stan Laurel.

BONUS

5. Terry Southern
Not only the screenwriter of *Dr. Strangelove*, but also the author of *The Magic Christian* and co-author of *Candy*, both of which were turned into films that starred Ringo.

6. Lenny Bruce
The brilliant but controversial and troubled comedian, seen by many as the father of modern stand-up, who died the year before *Sgt. Pepper* came out, aged 40.

7. WC Fields
Much-loved American film star and comedian famous for his absurd, left-field wisecracks.

8. Mae West
Notorious stage and screen vamp who famously said to Cary Grant, 'Come up and see me some time'.

9. Diana Dors
British film star and blonde bombshell whose appeal was modelled on Marilyn Monroe's.

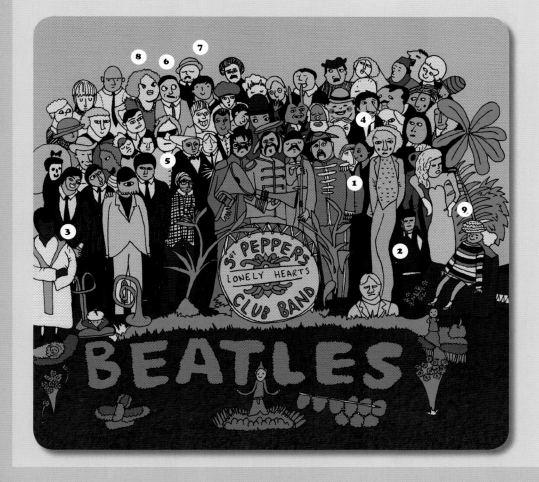

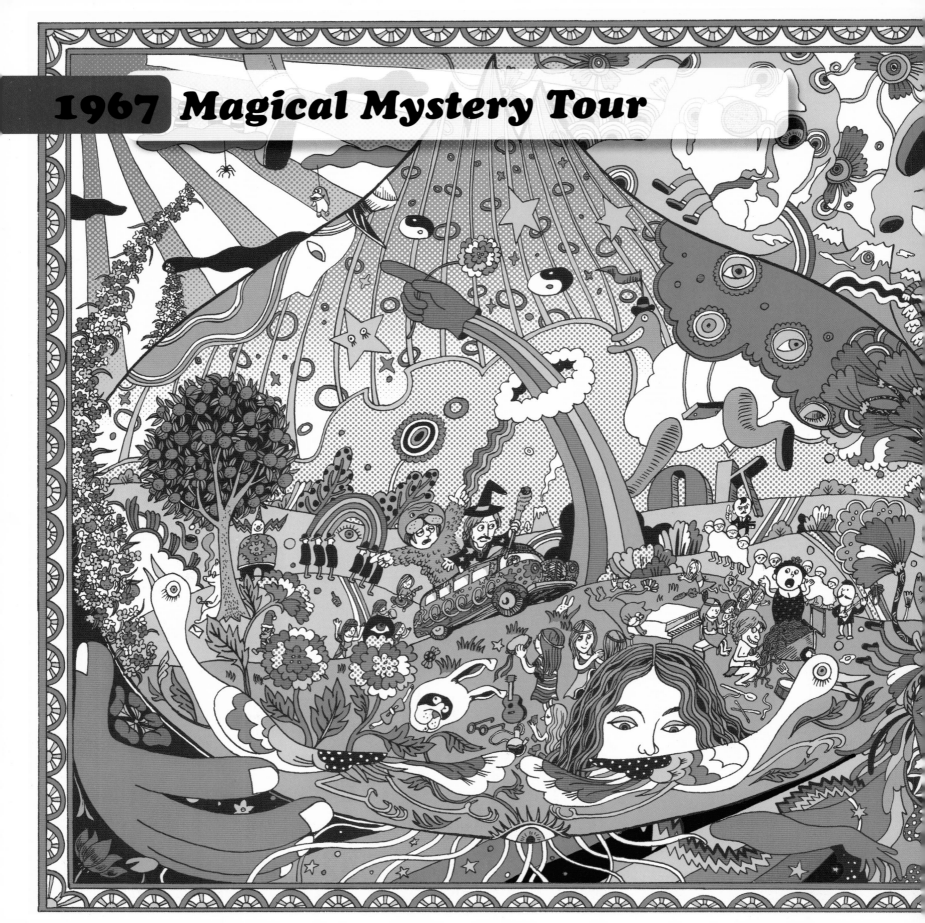

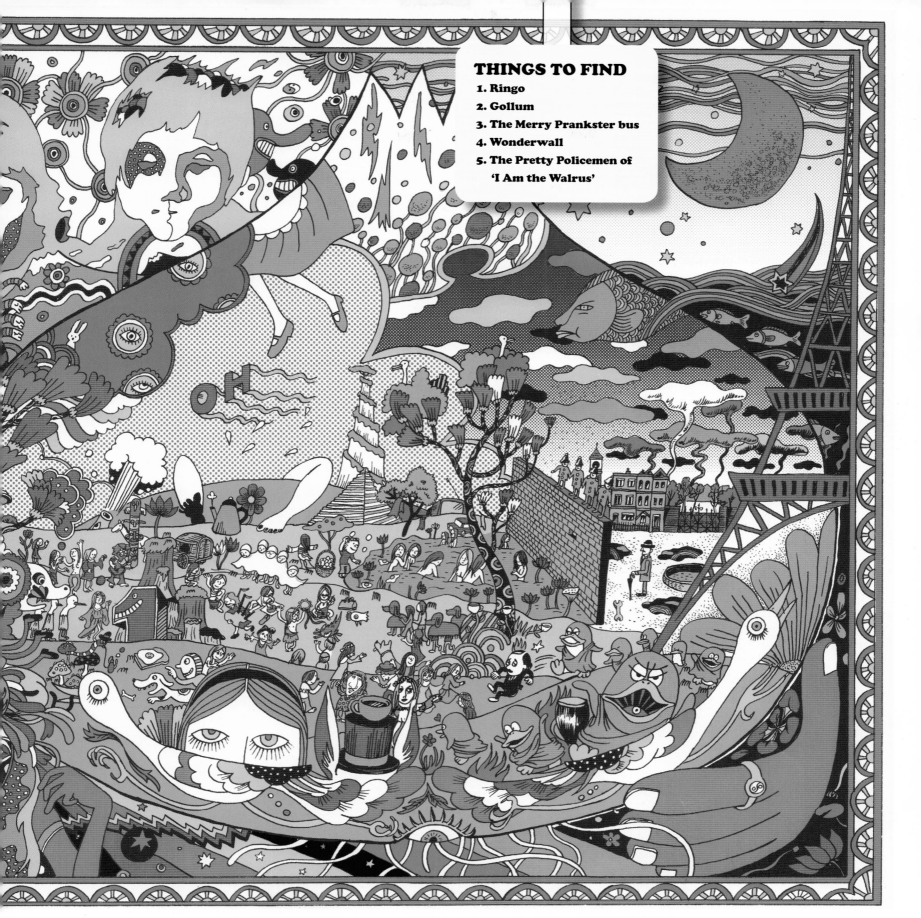

THINGS TO FIND
1. Ringo
2. Gollum
3. The Merry Prankster bus
4. Wonderwall
5. The Pretty Policemen of 'I Am the Walrus'

Magical Mystery Tour

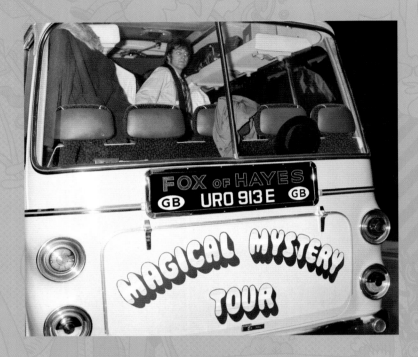

After George's wife Pattie learned about Transcendental Meditation, an Indian technique for inner peace popularised by the Maharishi Mahesh Yogi, George and the rest of the Beatles soon became interested and attended a seminar with the Maharishi on 25 August, 1967. Very sadly, it was the same weekend that their manager Brian Epstein overdosed on the sleeping pill Carbitral.

Brian's death would profoundly impact the group. Though his financial mismanagement cost the Beatles millions, he enabled them to focus purely on the music. When they were forced to deal with business, it gave rise to tensions that contributed to their breakup. But in the immediate aftermath of his funeral, the Beatles forged ahead with their latest project, a television special concocted by Paul, named *Magical Mystery Tour*.

In 1964 author Ken Kesey and his group of psychedelic partiers, the Merry Pranksters, crossed the United States in a school bus painted crazy colours and driven by Neal Cassady, inspiration for the hero of the Beat novel *On the Road*. The Beatles decided to emulate them by filling a bus (pictured above) with strange characters and heading out in the vein of the old charabanc mystery tours, an English tradition in which children took chaperoned trips

through the countryside, destination unknown. Except for the musical sequences, the film was too aimless for even hardcore fans and received scathing reviews when it premiered on the BBC on Boxing Day 1967. (Luckily, 1968's animated *Yellow Submarine* would better capture the essence of the band's psychedelic era.) Yet as dumb as the TV film was, its soundtrack album was often the first one selected by young fans of the next generation when they discovered the group, thanks to the cover's rainbow imagery, animal masks and promises of magic, echoed by its galvanising theme song in the 'Pepper' tradition.

The Beatles were joined by the Stones' Brian Jones and Mick Jagger for the laid-back groove of 'Baby You're a Rich Man', the B-side to 'All You Need Is Love'. It was one of the last songs to be stitched together from a verse by John and a chorus by Paul.

Above: The Magical Mystery Tour bus.

'Hello Goodbye' was not psychedelic but its B-side was the culmination of the group's fantasia period. 'I Am the Walrus' had its genesis when John received a letter from a student at his old Quarry Bank school that discussed how one teacher instructed students to analyse Beatle lyrics. At the same time, hippies were scrutinising each Beatle track for hidden meaning. According to his childhood friend Pete Shotton, John strung together random gobbledegook nonsense and grinned, 'Let the f---ers work that one out.'

In February 1968, John's snarling 'Hey Bulldog' signalled he was ready to clear his head and get back to basics after the *Magical Mystery Tour* debacle, and the rollicking single 'Lady Madonna' showed the same for Paul.

DID YOU FIND?

1. Ringo

2. Gollum
The Beatles' company Apple talked to Stanley Kubrick about directing the band in an adaptation of *The Lord of the Rings* – John would play Gollum, George would be Gandalf, Paul would be Frodo and Ringo would be Sam. Author JRR Tolkien nixed the idea.

3. The Merry Prankster bus (nicknamed 'Furthur')
Kesey and the Pranksters filmed their trips on Furthur, but the footage would not be assembled until the 2011 documentary *Magic Trip*. Still, Furthur's legend inspired the Doors' 'The End' and the Who's 'Magic Bus'. The Pranksters also rode Furthur to a Beatles concert in '65. The Beatlemaniacs freaked them out.

4. Wonderwall
George's first solo album, *Wonderwall Music*, was the instrumental soundtrack to the 1968 film *Wonderwall*, and inspired the 1995 Oasis song. It was the second Beatle solo album, following Paul's 1966 soundtrack for *The Family Way* starring Hayley Mills, notable for its haunting instrumental 'Love in the Open Air'.

5. The Pretty Policemen of 'I Am the Walrus'
John composed 'Walrus' to the rhythm of a police siren. Recently his friends the Rolling Stones had been arrested, and the song's ominous tone reflected the counterculture's growing paranoia of the police. Detective Norman Pilcher was famous for arresting pop stars and, a year after John slipped the line 'semolina pilchard' into 'Walrus', Pilcher arrested John and Yoko, and later George.

BONUS

6. Ringo's Aunt Jessie
During the production of *Magical Mystery Tour*, John dreamt he was a waiter endlessly shovelling spaghetti onto a lady's plate, so they filmed it with actress Jessie Robins playing Ringo's Aunt Jessie.

7. Apple Boutique mural
On 7 December, 1967, the Beatles opened a shop with clothes by Dutch designers The Fool and had a massive mural painted across the storefront. Unfortunately, the authorities painted over the mural the following May and the shop went out of business in July, its clothes given away free to the public.

8. Edgar Allen Poe
The master of the macabre made a guest appearance not only in the lyrics of 'Walrus' but also on the cover of *Pepper*.

9. Grace Slick
Jefferson Airplane's hit 'White Rabbit' was based on the classics *Alice in Wonderland* and *Through the Looking Glass* by Lewis Carroll (also on the cover of *Pepper*). Released on 24 June, 1967, the Slick-penned single perhaps galvanised John to write his own Carroll homage with 'Walrus'.

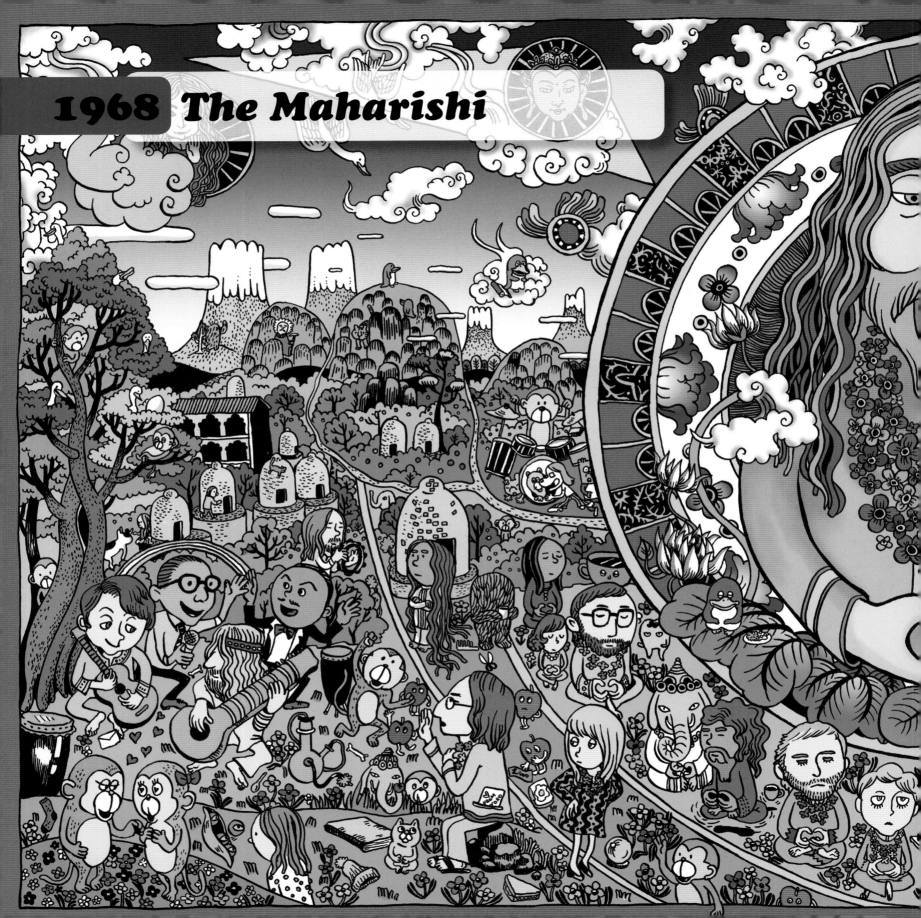

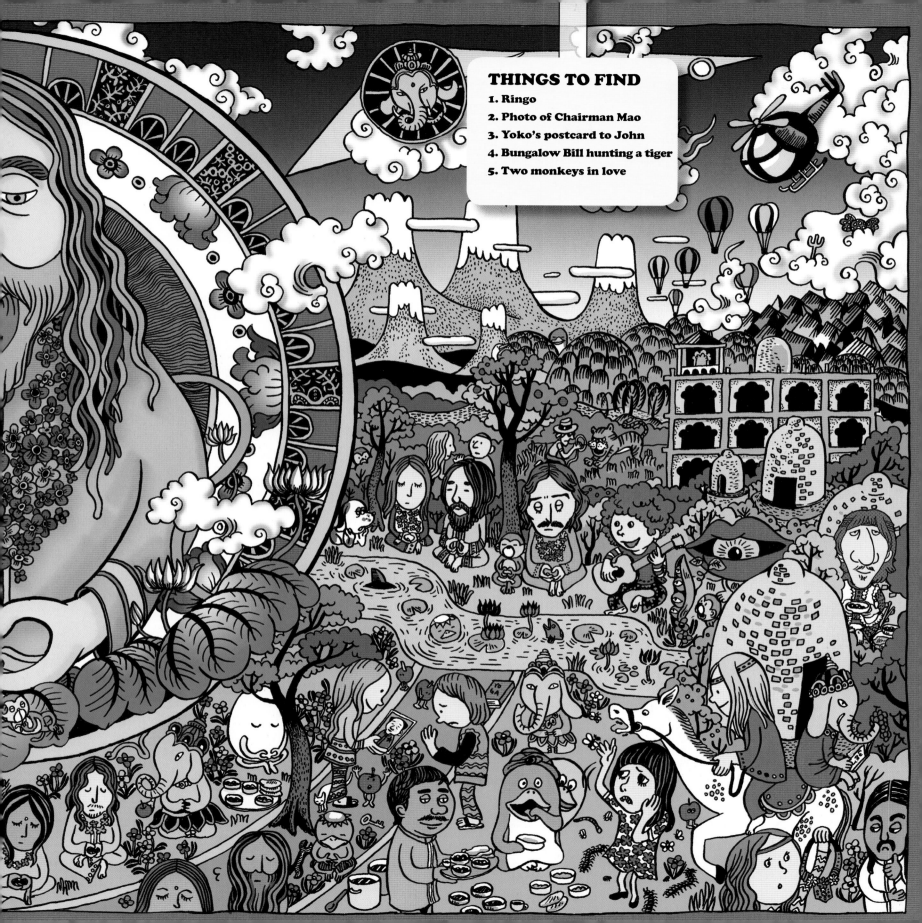

THINGS TO FIND

1. Ringo
2. Photo of Chairman Mao
3. Yoko's postcard to John
4. Bungalow Bill hunting a tiger
5. Two monkeys in love

The Maharishi

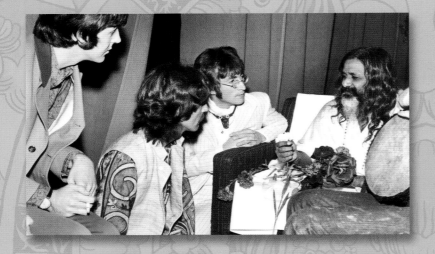

The Beatles had originally seen the Maharishi Mahesh Yogi on the news in the '50s. His name meant 'Great Seer who practised yoga and meditation', and he travelled the world teaching Transcendental Meditation, a technique where a mantra is repeated over and over so that no other thought can enter the mind.

After George's study of Indian instruments expanded to Indian spirituality, the group decided to hear the Maharishi speak in August 1967. In February 1968, the band flew to study at the Maharishi's fourteen-acre ashram in Rishikesh, India, at the foothills of the Himalayas beside the Ganges River. In the two weeks before their departure, John recorded the first version of 'Across the Universe', chanting 'Jai Guru Deva om', meaning 'all glory to Guru Dev', the Maharishi's original teacher. George's 'The Inner Light' took words of wisdom from the ancient Taoist holy book *Tao Te Ching*. (Ironically, the lyrics said that there was more wisdom to be found going nowhere instead of travelling.) George had recorded the Indian instrumentation while producing the soundtrack for the British film *Wonderwall*. Paul and John loved it, and encouraged him to sing at a higher key, a vocal technique that would flower with 'Something' and 'Here Comes the Sun'. It became George's first B-side, paired with 'Lady Madonna'.

John and George arrived with their wives at the Maharishi's camp on 16 February, with Paul, Ringo, Jane Asher and Maureen joining on 20 February. Musicians Donovan and Mike Love of the Beach Boys,

as well as actress Mia Farrow, also came along. Donovan recalled that when they first arrived at the Maharishi's quarters they were all a bit nervous, until John walked over to the cross-legged guru sitting on the floor and patted his head with, 'There's a good guru'.

Aside from meditation they had plenty of time to compose and, when they met for their next album, George had five tracks, Paul seven and John fourteen. Twenty-two of those songs would make it onto the thirty-song double LP *The Beatles* (aka *The White Album*). Paul's 'Why Don't We Do It in the Road' was inspired by two monkeys he saw doing just that. George's haunting 'Long, Long, Long' begat his tradition of songs that could be interpreted as him singing to either God or to his woman, a mainstay of his solo career. As for Ringo, he completed his first solo composition, the country and western pastiche 'Don't Pass Me By'.

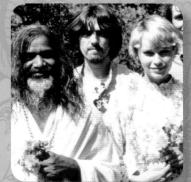

Top: The Beatles with Maharishi in London; bottom right: the Maharishi, George Harrison and Mia Farrow at Rishikesh, India.

The trip was the last idyllic moment of unity for the band. John left with mixed feelings towards the Maharishi, however. He felt he wanted them to donate too much of their income, and there was a rumour that the guru had made a pass at Mia Farrow. John also yearned to get back to his new love, Yoko Ono. On leaving, he wrote the disillusioned 'Maharishi', but changed it to 'Sexy Sadie'. Paul and Ringo never became as serious about meditation as George, but continue to extol the practice to this day.

DID YOU FIND?

1. Ringo
The vegetarian food gave him a stomach ache, the insects freaked Maureen out and they missed their kids, so they left early.

2. Photo of Chairman Mao
The United States draft made radical groups want to overthrow the government. With 'Revolution' John hoped to have it both ways: scaring the straights with the song's title and distorted guitar (some copies were returned because people thought they were defective), while lyrically advocating against destruction and chiding the radicals for romanticizing Chairman Mao of China.

3. Yoko's postcard
When the Maharishi asked which Beatle wanted to join him for a helicopter ride, John jumped in because 'I thought he might slip me the Answer'. But John was realising more and more that his answer was actually the crazy artist Yoko sending him postcards in India that read things like, 'Watch for me, I'm a cloud in the sky'. When John wrote his hymn to his late mother Julia, he entwined her name with 'Ocean Child', the Japanese translation of Yoko.

4. Bungalow Bill hunting a tiger
Richard A Cooke III was the American son of the Maharishi's publicist. He took a break from meditating to go shoot a tiger for sport, which John didn't find very spiritual, inspiring 'The Continuing Story of Bungalow Bill'.

5. Two monkeys in love
'Why Don't We Do It in the Road' was inspired by two monkeys Paul saw doing just that.

BONUS

6. Mia Farrow
She came to get over her divorce from Frank Sinatra (29 years her senior). He had served her papers while she shot *Rosemary's Baby*. Mia's sister also attended and inspired John's pastoral 'Dear Prudence'.

7. Mike Love
When Paul wrote 'Back in the USSR', the Beach Boy Mike Love suggested adding some lines praising Russian women, à la 'California Girls'.

8. John's amulet
John wore this mysterious necklace in 1967 and 1968; it was the only thing he wore on the cover of *Two Virgins* in which he and Yoko appeared nude. Magic Alex later auctioned it at Christie's for £117,250 (approximately $180,000). Oasis' Noel Gallagher bought it for his brother Liam as a Christmas present.

9. Jimmy Scott
Paul heard the saying 'Ob-La-Di, Ob-La-Da, life goes on' from Nigerian musician Scott, who plays congas on an early version of the song included in *Anthology 1*.

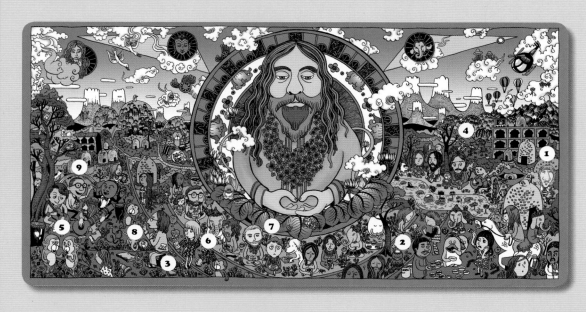

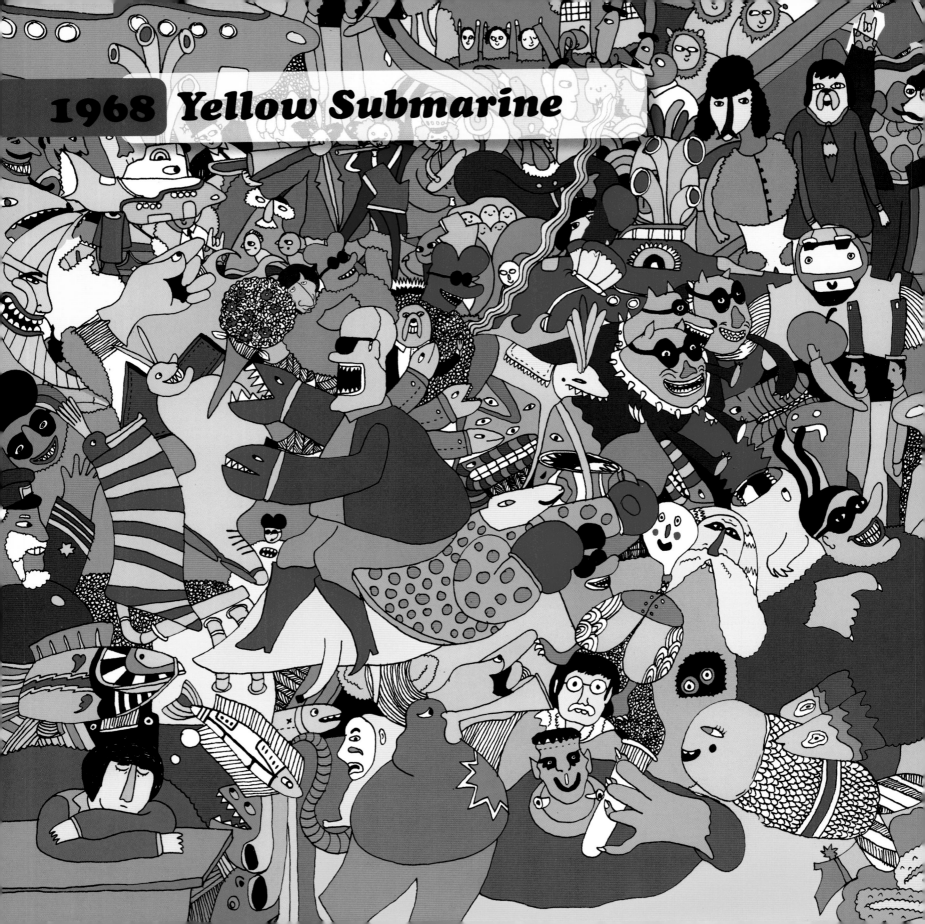

1968 *Yellow Submarine*

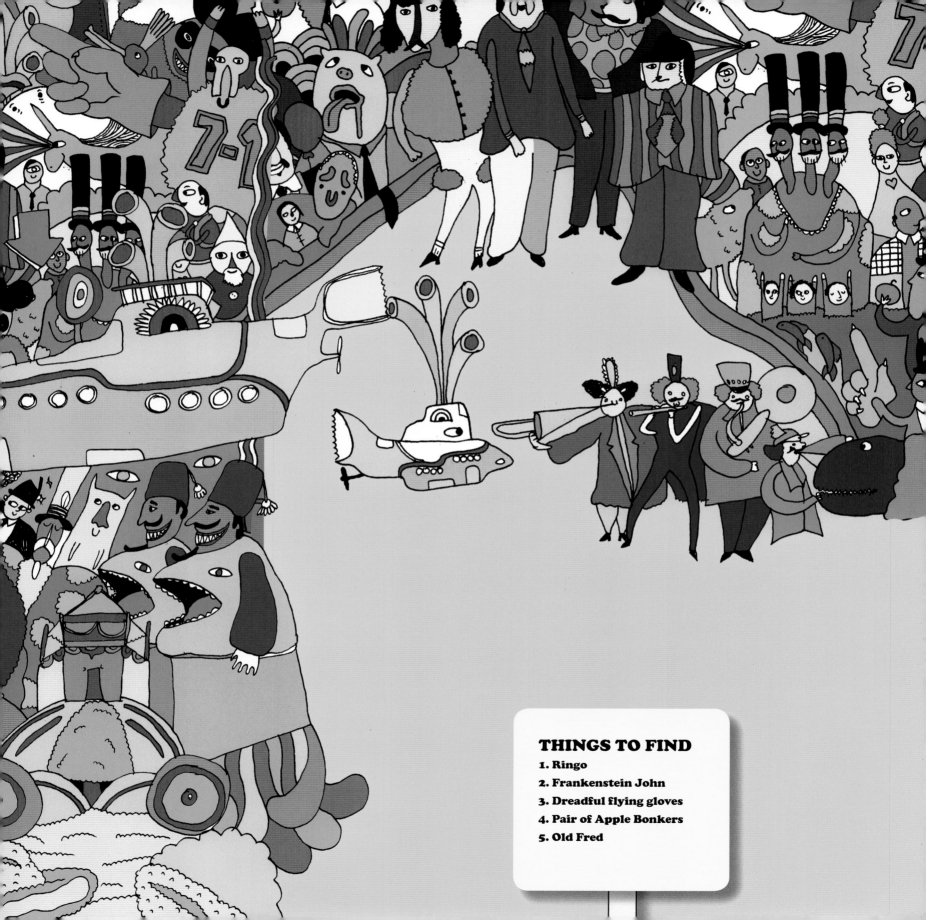

THINGS TO FIND
1. Ringo
2. Frankenstein John
3. Dreadful flying gloves
4. Pair of Apple Bonkers
5. Old Fred

Yellow Submarine

The animated musical fantasy film *Yellow Submarine* burst onto British cinema screens in the summer of 1968 (and in November 1968 in the United States) – a surreal explosion of new wave psychedelic art that captivated audiences and captured the vibe of the flower-power era.

The Beatles barely participated in the production of *Yellow Submarine*. They hadn't enjoyed making their 1965 film *Help!*, and their 1967 TV special *Magical Mystery Tour* had been poorly received. *Yellow Submarine*'s producer, Al Brodax, was also the creator of the Saturday morning cartoon series *The Beatles* (1965–69). They weren't keen on that show's depiction of their early moptop incarnation, with Ringo the moronic butt of most jokes. So actors were found to provide voices for the animated Beatles, and the group itself only appeared for one minute at the end of the film.

Thus they were relieved to find they enjoyed the movie, which premiered on 17 July, 1968. It was the perfect encapsulation of their psychedelic era. Released on 13 November in the States, *Time* magazine proclaimed it a 'smash hit, delighting adolescents and esthetes alike'.

Inspired by Paul's song 'Yellow Submarine' from *Revolver*, writer Lee Minoff came up with the original story and the script was completed by Brodax, *The Beatles* TV series writer Jack Mendelsohn, Erich Segal (later to pen the 1970 novel *Love Story*) and British poet Roger McGough.

The film begins when a tribe of music-hating, apple-wielding Blue Meanies attacks Pepperland, a music-loving paradise under the sea. It falls to Pepperland's Old Fred to seek help. He escapes in a yellow submarine to Liverpool, where he finds Ringo wandering aimlessly, recalling his solo scenes in *A Hard Day's Night*.

The band heads back to Pepperland in the yellow submarine through different seas. When the group rocks out with 'Sgt. Pepper's Lonely Hearts Club Band', they rally the Pepperlanders and force the Blue Meanies to retreat.

Director George Dunning oversaw 200 artists for 11 months while a variety of animators took charge of specific sequences. The art director was German illustrator Heinz Edelmann, who designed the Blue Meanies and Nowhere Man.

Yellow Submarine's look was in contrast to the prevalent Disney style of the day, in part due to its use of limited animation, which reused common elements between film frames rather than redrawing them entirely. It was a cheaper approach but a more creative, quirky one, and would be a major influence on Terry Gilliam's Monty Python cut-outs.

Top: Yellow Submarine *album artwork; bottom right:* Yellow Submarine *film poster.*

DID YOU FIND?

1. Ringo
When Ringo presses the submarine's panic button he is ejected into the Sea of Monsters. From then on real-life kids would ask him, 'Why did you press the button?'

2. Frankenstein John
When Ringo searches for John, he finds the Frankenstein Monster instead – until the Monster drinks a potion and morphs into John, like a reverse Dr Jekyll. Like the Monster, John was abandoned by his folks and known to go on a violent rampage now and then. The potion hinted at the Summer of Love's belief in better living through chemistry to transcend one's dark side.

3. The Dreadful Flying Gloves
The most formidable Blue Meanie is a giant blue that turns itself into a fist to smash its enemies – until John defeats it by singing 'All You Need Is Love'.

4. Pair of Apple Bonkers
These Blue Meanies carry giant green apples to drop on their victims. The apples look like the logo of the Beatles' Apple Records. At the time of the movie's release, the Beatles were excited about the possibilities of their label. Within a year, however, business woes would leave the group feeling like they'd been bonked on the head.

5. Old Fred
English comedian Lance Percival supplied his voice, as he had done for Paul and Ringo on the Beatles' Saturday morning cartoon show. Percival also recorded comedy songs with Beatles producer George Martin.

BONUS

6. Red submarine
While living with girlfriend Jane Asher's family in London, Paul was drifting off to sleep one night when he started envisioning an ancient mariner telling children about his life living in submarines. Originally the lyrics included different coloured subs, but eventually the concept was simplified to just one.

7. Snapping-Turtle Turks
Their favourite activity is to make little girls cry by eating their pinwheels.

8. Butterfly
The Butterfly Stompers were cat-faced creatures that loved to jump on butterflies and crush them … but this butterfly escaped!

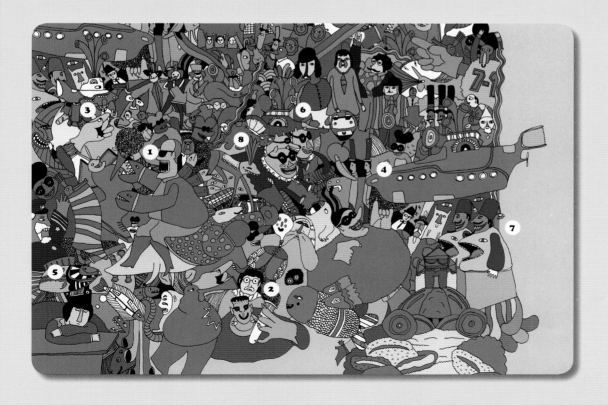

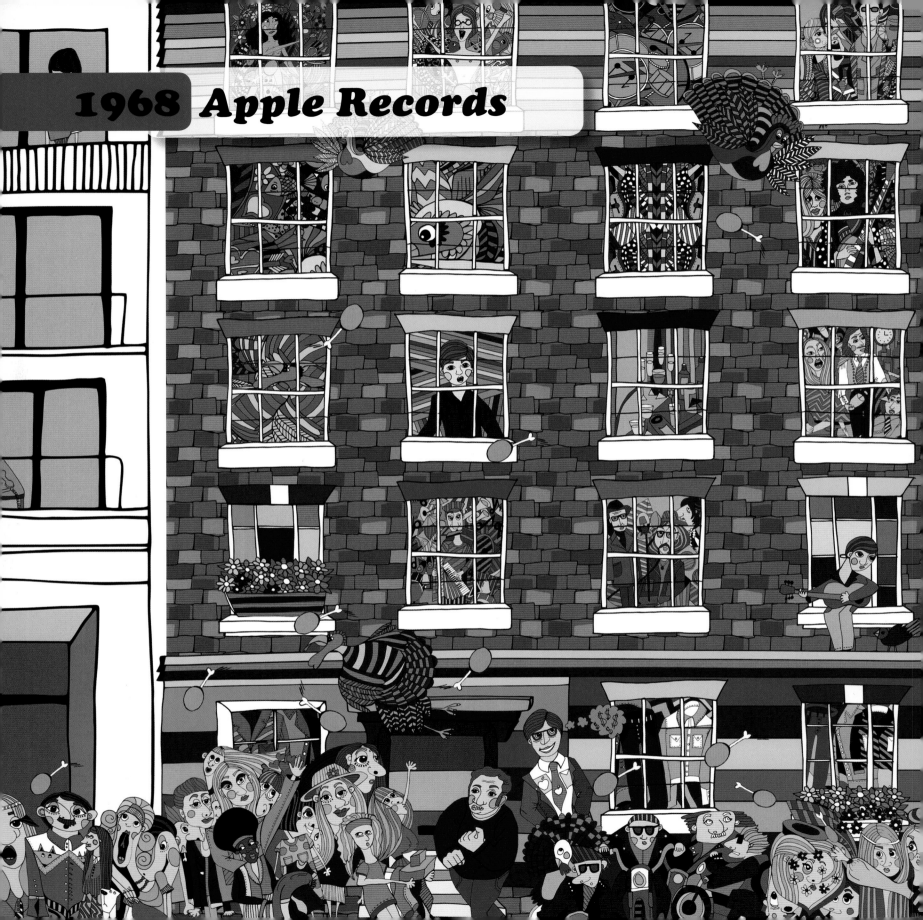

1968 **Apple Records**

When the British government told the Beatles that they could either pay a huge portion of their earnings to taxes or use the money to start a business, the group chose the latter.

They initially envisioned Apple Corps Ltd (a typical Beatle pun) as a place where they could offer musicians, filmmakers and designers more freedom than typical corporations – 'Western communism', Paul dubbed it at the press conference announcing its formation on 14 May, 1968. Some of the label's discoveries included James Taylor, Badfinger and Mary Hopkin. Future Beatle collaborator Billy Preston was also signed.

Apple released the double album *The Beatles* on November 22, 1968. It was soon renamed *The White Album* by the public, due to its all-white cover by

THINGS TO FIND

1. **Ringo**
2. **Hell's Angels**
3. **Eric Clapton and Pattie Harrison**
4. **John and Yoko nude**
5. **Blackbird**
6. **A (very) young Steve Jobs**

Apple Records

Left: Apple Records signing Mary Hopkin (left) with model Twiggy (right) who introduced her to the Beatles.

Richard Hamilton, it was designed to be the extreme opposite of the sleeve for *Sgt. Pepper*. Throughout much of 1969 John and Yoko would be photographed clad only in white.

It is perhaps the Beatles' most topical album, with many of the tracks addressing the social unrest of the day, from John's consideration of 'Revolution' to Paul's tribute to the civil rights movement, 'Blackbird'. Many of the tracks were acoustic or stripped down, heading away from the kaleidoscopic instrumentation of 1967 toward the minimalism of next year's *Get Back* project. At the same time, they rocked harder than ever, striving to keep pace with contemporaries like the Who, Jimi Hendrix and Cream in tracks like 'Helter Skelter' and 'Yer Blues'.

As the band cruised through ska, proto-metal, doo-wop, surf rock, music hall, folk, blues and country, the collection's wild eclecticism prompted *Rolling Stone* editor Jann Wenner to proclaim the album 'the history and synthesis of Western music'.

George Martin, however, felt the collection would have been better had it been cut down to a single disc. And amidst the dazzling array of styles, the absence of a straightforward love song is felt. Ironically, one of the greatest love songs of their generation, 'Hey Jude', was recorded during the same sessions but left off to serve as the single.

Had the group heeded Martin, cut the album down to its crème de la crème, and sequenced it to reflect the escalating tumult of its year – 'Back in the USSR', 'Dear Prudence', 'Ob-La-di Ob-La-Da', 'Yer Blues', 'Birthday', 'Sexy Sadie', 'Blackbird', 'Piggies', 'Revolution' (the single version), 'Helter Skelter', 'Happiness is a Warm Gun', 'While My Guitar Gently Weeps', climaxing with 'Hey Jude' – it would quite possibly be regarded as rock's finest album. But years later Paul would maintain it was fine as is, in all its chaotic brilliance: 'It's the bloody Beatles' *White Album*. Shut up'.

DID YOU FIND?

1. Ringo

Ringo became friends with Peter Sellars on the first film he did without the other Beatles, 1968's *Candy*, based on the controversial novel by *Dr Strangelove* screenwriter Terry Southern (who featured on the cover of *Sgt. Pepper*) and Mason Hoffenberg. Ringo and Sellars would re-team in Southern's *The Magic Christian* in 1969.

2. Hell's Angels

George met the infamous biker gang in California in the autumn of 1968 and made the mistake of inviting them to Apple. They terrorised the 1968 office Christmas party and ate all the turkey.

3. Eric Clapton and Pattie Harrison

Eric Clapton and George Harrison stayed close friends even after Clapton married Pattie, George's ex-wife, in 1979. George invited Clapton to play on 'While My Guitar Gently Weeps', and Clapton's sweet tooth inspired 'Savoy Truffle'.

4. John and Yoko nude

They appeared nude on the cover of their 1968 album *Two Virgins*.

5. Blackbird

McCartney wrote in his memoir that he wrote the song as a show of solidarity with black women fighting for civil rights in the United States.

6. A (very) young Steve Jobs

In 1976 Jobs and Steve Wozniak named their computer company Apple. In 2007 Apple Computers had to pay Apple Corps approximately $500 million for the trademark. So the Beatles' company did make a little cash after all.

BONUS

7. The one-man band

The Beatles naively placed an ad featuring a one-man band inviting artists to submit their works to Apple. They were instantly besieged with more music, scripts and books than they were ever able to review.

8. Apple Scruffs

This clique of hardcore female fans hung around Apple Records and Abbey Road Studios in the hopes of getting to chat with the Fabs. Some got to sing background on the original version of John's 'Across the Universe'. George wrote a song about them, 'Apple Scruffs', for his first solo album.

9. William Burroughs

One of the founding fathers of the Beat Generation, he appeared on the *Sgt. Pepper* cover beneath fellow morbid poet Edgar Allen Poe. Paul hoped to record him for Apple's spoken word label, but that division never got off the ground.

10. Allen Klein

Apple was in danger of going broke from all the freeloading. Klein had managed Sam Cooke and the Stones, and John wanted him as manager, but Paul didn't trust him. Paul's caution was probably justified – Klein ended up owning all the Stones' music recorded before 1971.

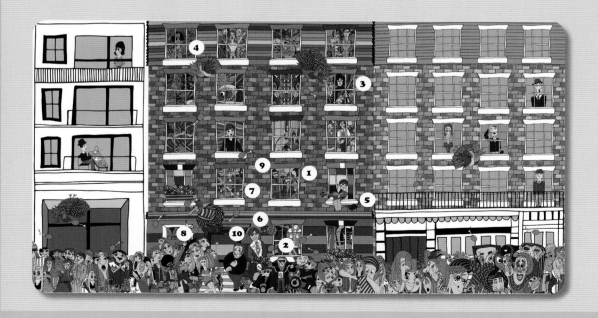

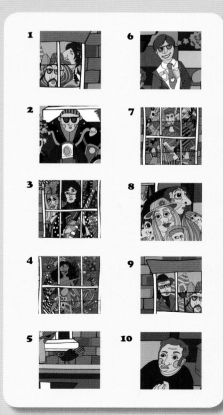

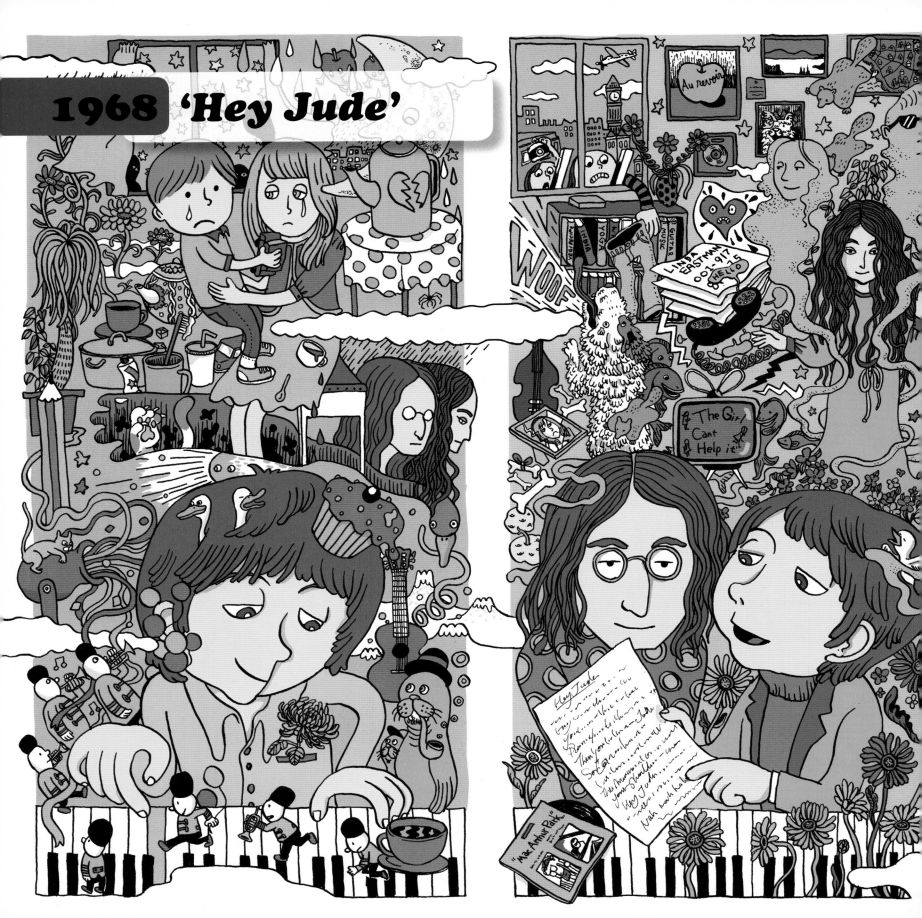

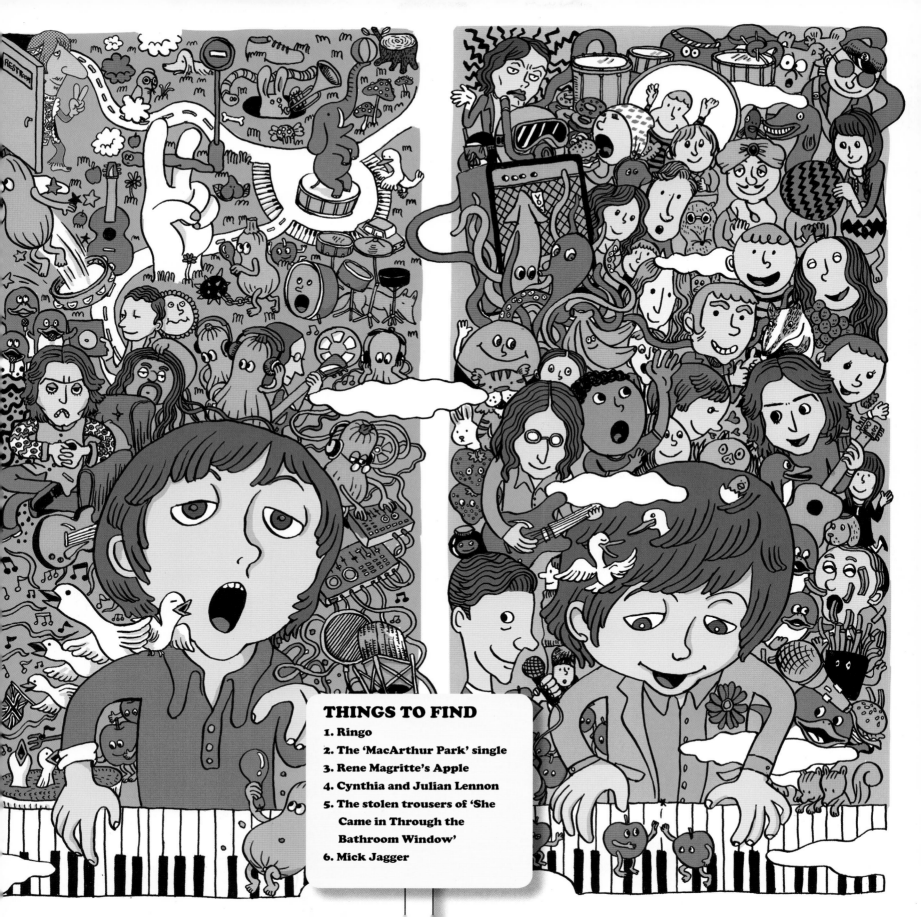

THINGS TO FIND

1. Ringo
2. The 'MacArthur Park' single
3. Rene Magritte's Apple
4. Cynthia and Julian Lennon
5. The stolen trousers of 'She Came in Through the Bathroom Window'
6. Mick Jagger

'Hey Jude'

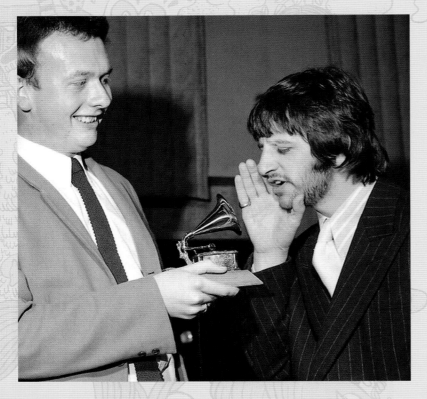

On 19 May, 1968, while Cynthia and Julian were on holiday, John invited Yoko over to his house. In his home studio they recorded the experimental album *Unfinished Music No. 1: Two Virgins* together.

Good with kids, in many ways he enjoyed a better rapport with Julian than John did. On his way there he improvised the first two lines of the song, but addressed them to 'Jules' rather than 'Jude'.

John and Yoko stayed at Paul's home on Cavendish Avenue while they searched for their own place and Paul played his new composition for them. 'I took it very personally. 'Ah, it's me', I said', John recalled. 'He says, 'No, it's me'. I said, 'Check. We're going through the same bit'.'

Paul was embarrassed by his line about 'the movement' being on Jude's shoulder, and told John it was just a placeholder. But John insisted it was the best line in the song. In the next four years John and Yoko would devote themselves to the peace movement.

John later proclaimed it Paul's best song. 'Yoko's just come into the picture. He's saying, "Hey Jude" – "Hey John". I know I'm sounding like one of those fans who reads things into it, but you can hear it as a song to me. The words "go out and get her" – subconsciously he was saying, "Go ahead, leave me". On a conscious level, he didn't want me to go ahead. The angel in him was saying, "Bless you". The devil in him didn't like it at all, because he didn't want to lose his partner.'

Now assured that he was indeed in love, John resolved to leave his wife for Yoko, though it was a prospect that filled him with dread because he knew the public and the press would crucify him for it (as he indeed sang the following year in 'The Ballad of John and Yoko'). In the demos for 'Happiness is a Warm Gun' included on *Anthology 3*, he makes a pun on Yoko's name, singing 'oh no' at first, and then 'oh yes'.

It wasn't a lighthearted time for Paul, either. On 20 July, Jane Asher announced to the press that their engagement was over. He had been hesitant and, ultimately, she caught him in bed with another woman. Melancholy, he drove out to see Cynthia and Julian, not wanting to disappear on them after so many years of being close.

Above: The Beatles' sound designer Geoff Emerick (plus Grammy award he won for Sgt. Pepper*) with Ringo.*

Perhaps that accounts for the near 'Judas' of the title, calling John out for 'betraying' his family and (soon enough) Paul with the woman who replaced them both. Ironic, then, that the song was the band's majestic climax as a brotherhood on the eve of their final year. It wasn't quite such a dark time, however, for Ringo. He was still happily married to Maureen and by now they had two sons (a daughter would follow in 1970), and offers of film work were coming in. He would soon live up to his stage name (and the lyrics of 'Act Naturally') by becoming a film actor, independently of Beatles movies.

DID YOU FIND?

1. Ringo
When recording 'Hey Jude', Ringo snuck out to relieve himself and then tiptoed back just in time for his entrance 50 seconds into the track. Paul remembered afterwards laughing to himself and thinking, 'This has got to be the take, what just happened was so magic!'

2. The 'MacArthur Park' single
The actor Richard Harris (who would go on to play Dumbledore in the first two *Harry Potter* films) had a hit in 1968 with the song 'MacArthur Park', which broke radio convention by running 7 minutes 21 seconds. The Beatles strove to tie it (running close at 7:11).

3. René Magritte's Apple
Art dealer Robert Fraser was a member of the Beatles' and Rolling Stones' inner circle. He gave Paul the painting that inspired Apple Corps' label.

4. Cynthia and Julian Lennon

5. The stolen trousers of 'She Came In Through the Bathroom Window'
The Apple Scruffs spawned this *Abbey Road* track when they snuck into Paul's house and swiped his trousers, which they took turns wearing.

6. Mick Jagger
Mick held his 25th birthday at London's Vesuvius nightclub and played everyone the Stones' new album, *Beggar's Banquet*. Then Paul asked the DJ to put on 'Hey Jude' and blew everyone away. In November the Stones attempted to top the song with their own cathartic masterpiece, 'You Can't Always Get What You Want'.

BONUS

7. Ghosts of Julia Lennon and Stu Sutcliffe
In *The White Album*'s 'Julia', John intertwined the name of his mother with the translation of the name Yoko ('Ocean Child'). Like his mother, Yoko defied convention with outrageous humour. And she was an artist like John's late best friend Stu Sutcliffe, the other person who had once competed with Paul for John's attention.

8. Photo of Jane Asher
Paul wanted his woman by his side 'here, there and everywhere', but Jane was committed to a career that required frequent travel.

9. Martha
Paul wrote 'Martha My Dear' for his beloved sheepdog. 'Our relationship was platonic, believe me'.

10. *The Girl Can't Help It*
The band watched this '50s rock film (featuring Little Richard, Fats Domino and Eddie Cochran) at Paul's then went to Abbey Road and improvised 'Birthday'.

In 1969 Paul was itching to go back on tour (like their rivals the Rolling Stones soon would) but the other three vetoed the idea. John would never tour again. George only toured two more times in his life, a 30-day tour of North America in 1974 with Ravi Shankar and Billy Preston, and a 12-day tour of Japan with Eric Clapton in 1991. Ringo would eventually return to regular live performances with his All-Starr Band ... twenty years later.

Instead they agreed to film the making of their next album, which would climax with a live performance on the rooftop of Apple Records in the heart of London. The initial idea was for the entire album to be recorded live in the studio. Getting back to basics had grown trendy ever since Bob Dylan countered the super-produced *Sgt. Pepper* with the bare-bones *John Wesley Harding* (1967), with just him, a bassist, and a drummer.

Paul had already soulfully warbled 'Can You Take Me Back' on *The White Album*. In George's 1968 composition for Apple artist Jackie Lomax, 'Sour Milk Sea', he advised listeners to get back to where they should be (via meditation). Paul returned to the theme again with 'Get Back', the galvanising theme song of the new enterprise.

To reaffirm their unity as a band they recorded countless old rockers from their Hamburg and Cavern days. They all loved the songs of their youth equally – in their solo years they would each (with the exception of George) release collections of rock and roll oldies.

John and Paul also unearthed a song they had written in 1957, 'The One After 909', and transformed it into a raucous powerhouse. The highlight was the electrifying 'Don't Let Me Down', in which John beseeched Yoko not to make a fool out of him now that he'd left his wife and risked his career for her.

THINGS TO FIND

1. **Ringo**
2. **Hare Krishnas**
3. **Raquel Welch**
4. **U2**

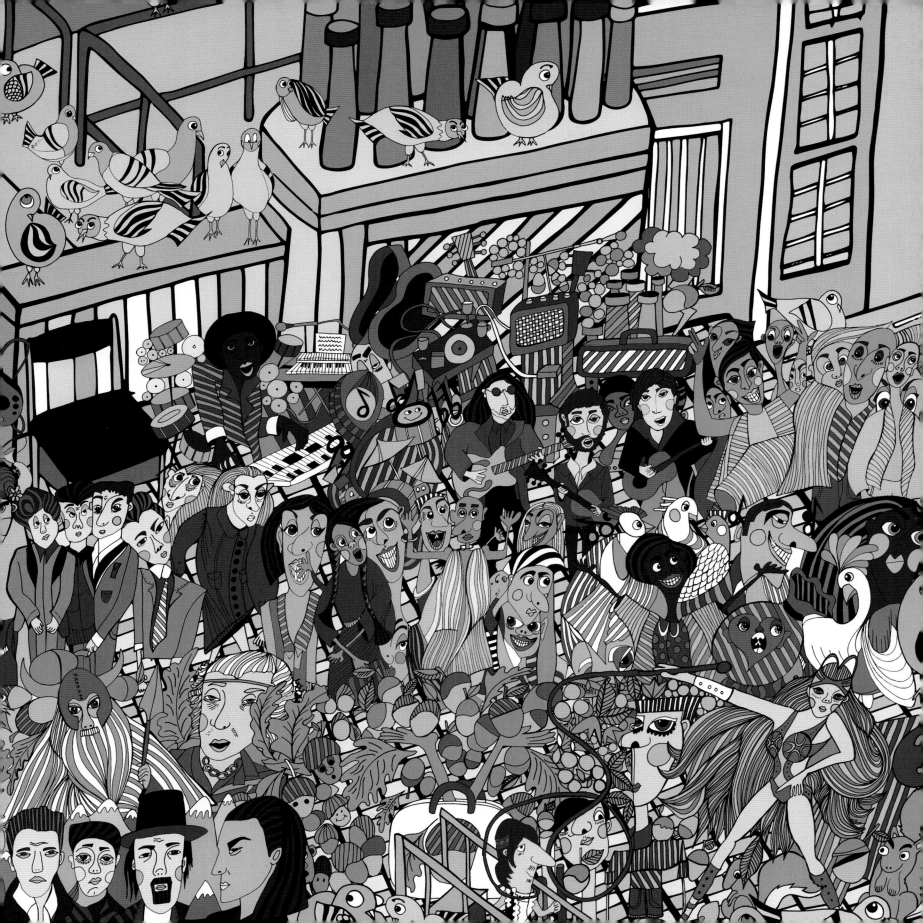

The Beatles' final rooftop concert

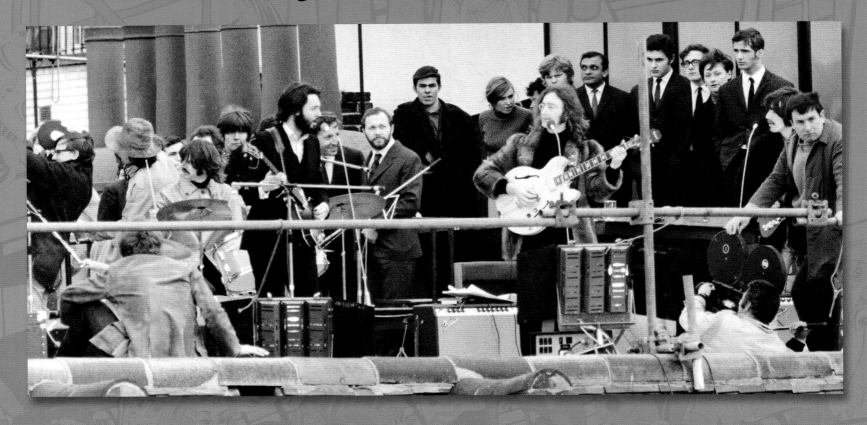

After writing many of the greatest love songs ever written, he had at last found his Juliet.

The band had once been able to knock out songs like 'Twist and Shout' in one take because they were playing live nightly, but those days were gone. The group was unhappy with the *Get Back* sessions and the tapes sat on the shelf for a year. Eventually John gave them to producer Phil Spector. The resultant album, *Let It Be*, was released in May 1970, seven months after the band's true final record, *Abbey Road*.

Paul was a perfectionist with his songs – most famously, he rejected George's suggestions for guitar parts on 'Hey Jude' – and was thus appalled when Spector added an orchestra, harps and a women's choir to 'The Long and Winding Road' without asking him. Paul would later remix the album as *Let It Be ... Naked* in 2003.

Top: Concert on the roof of Apple Records; bottom right: Phil Spector.

DID YOU FIND?

1. Ringo

2. Hare Krishnas

George chilled out with the help of the Hare Krishnas. He produced the Radha Krishna Temple's 'Hare Krishna Mantra' single and in August 1969 it made it to No. 12 in the UK.

3. Raquel Welch

She was in *The Magic Christian* alongside Ringo. For the soundtrack, Paul wrote 'Come and Get It' – the lyrics, in which the singer offers to give his money away, mirrored both the movie and Apple (until the Beatles suddenly realised their label was going broke fast).

4. U2

The Irish band attempted to claim the Beatles' mantle when they did their own rooftop concert in their 1988 film *Rattle and Hum*. Like the Beatles, they had two members bonded by the loss of their mothers during their teenage years – Bono and drummer Larry Mullen.

BONUS

5. Yoko hiding in a white bag

On 1 July, 1968, John and Yoko promoted their first joint art exhibition by releasing 365 white balloons with cards attached reading 'You Are Here' and an address to write John on the back.

6. Billy Preston

George noticed the band was more cordial with each other when he brought Eric Clapton in to help out on 'While My Guitar Gently Weeps' so in the *Get Back* sessions, he brought in their old friend Billy Preston.

7. Timothy Leary

The psychedelic proselytiser planned to run for governor against Ronald Reagan and came up with the slogan 'Come Together, Join the Party'. He asked John to write a song for it, but was then arrested. John used it for *Abbey Road*'s opening track.

8. Moondog

On a few appearances in 1958 John, Paul and George called themselves Johnny and the Moondogs, after DJ Alan Freed's *Moondog Show*. Freed was American but his show was broadcast in the British Isles. In the '50s he helped popularise rhythm and blues with white American kids by rebranding it as 'rock and roll' instead of R&B. He got the name 'Moondog' from 'Moondog's symphony' by blind American composer Louis 'Moondog' Hardin, who was known for wearing a horned headpiece and beard like the Norse god Odin.

9. Teddy boys

Paul wrote 'Teddy Boy' (based on the British Teddy boy phenomenon of Paul's youth) in India and tried to record it during the *Get Back* sessions, but John made fun of it (captured on *Anthology 3*) so Paul dropped it until his first solo album. One of the things Paul lost in the breakup was having John around to reign in his twee tendencies.

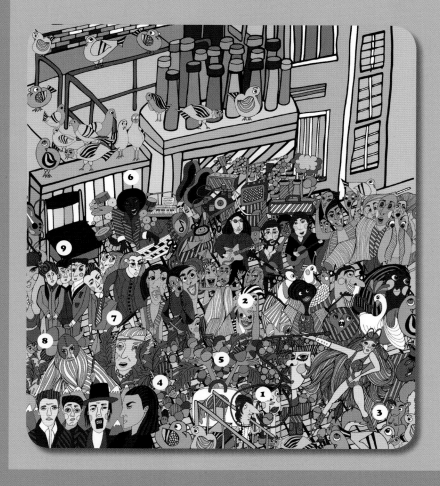

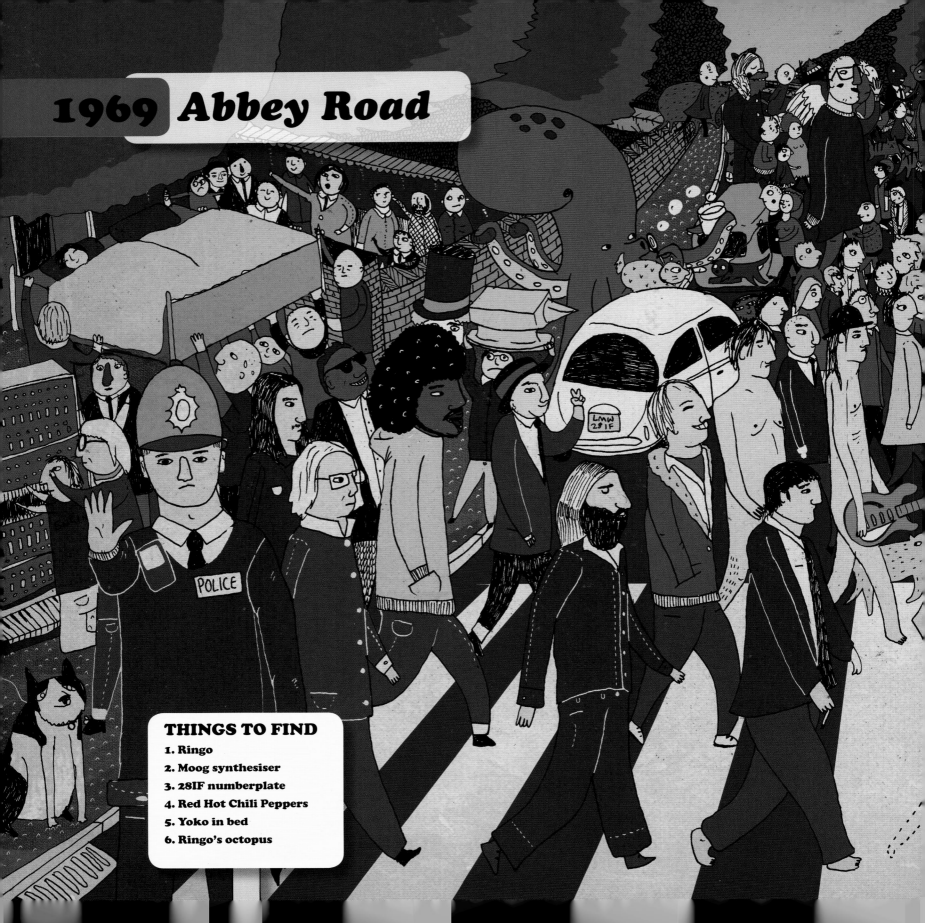

1969 Abbey Road

THINGS TO FIND
1. Ringo
2. Moog synthesiser
3. 28IF numberplate
4. Red Hot Chili Peppers
5. Yoko in bed
6. Ringo's octopus

Paul had sensed John fading away ever since 'Hey Jude', and had hoped that returning to their rock roots on *Get Back* would reignite their camaraderie. He sang optimistically that they were on their way home in 'Two of Us', home for Paul being his partnership with John. 'The Long and Winding Road' asked to be taken back inside as well.

The day Paul wrote 'Road' he also wrote 'Let It Be', after a dream in which his late mother Mary visited him. Perhaps the slow death of his band reminded his subconscious of the earlier devastating loss. In the dream she advised him not to worry so much about the Beatles, to just 'let it be' for a while. In the 21st century, bands regularly take a couple years off and give themselves a break from each other. But Paul pushed the others to the *Get Back* sessions two and a half months

Abbey Road

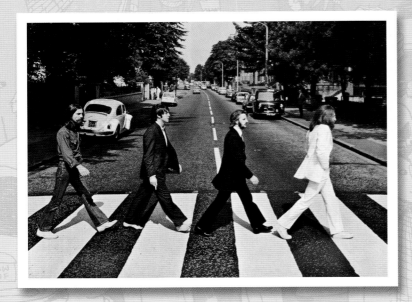

Above: The photograph used on the cover of Abbey Road.

after they wrapped *The White Album*, and *Abbey Road* two months after *Get Back*.

The group's staggering success allowed Paul to take longer and longer in the studio and he drove the others nuts, spending 42 hours on 'Ob-La-Di, Ob-La-Da' and 16 takes on 'Maxwell's Silver Hammer'. John avoided participating in the latter track. The Beatles had originally been John's band, but now he was often just a sideman. John wanted Yoko in the studio with him, but her relations with his former brotherhood (except Ringo) were frosty at best. As they reunited for *Abbey Road* (pictured above), they all partly sensed it was the last hurrah.

Abbey Road chronicles Paul's gradual acceptance of John's emotional departure. 'You Never Give Me Your Money' reflected how business tensions were the final straw that broke the Beatles' back. At the end of the song he tried to embrace the bright side of leaving the

Beatles behind and escaping to his Scottish farm with Linda and their growing family. With 'Golden Slumbers/Carry That Weight/The End', he finally accepted there was no way to get back to his old home, the band. The four joined in for one final jam (with Ringo's one and only drum solo) before closing with Paul's karmic reminder that the love you receive is equal to the love you give, his attempt at summing up their experience with a Shakespearean couplet.

John told the other Beatles he was quitting in September, but manager Allen Klein made him keep it quiet so he could get a better royalty rate for the group.

Paul announced the breakup during the release of his first solo album, *McCartney* (1970). Post breakup, the band famously argued with each other on record, like latter-day rappers dissing each other, in songs like 'Too Many People' (Paul), 'How Do You Sleep' (John), 'Back Off Boogaloo' (Ringo) and 'Wah-Wah' (George).

By 1973 they had made their peace. They occasionally appeared on each others' records, with Ringo's 'I'm the Greatest' and George's 'All Those Years Ago' featuring three out of the four. John and Paul can only be heard together again on the bootleg of a 1974 jam session. John's death in 1980 made a reunion impossible, but in the mid-'90s the others helped turn John's demos 'Free as a Bird' and 'Real Love' into singles.

In 'Come Together' John sang that one thing he could tell us was that we had to be free. The world was certainly a lot freer when he sang those lines than it had been when the Beatles first released 'Love Me Do' in 1962 – musically, fashion wise, romantically, spiritually. Mission accomplished.

DID YOU FIND?

1. Ringo

2. Moog synthesiser
Harrison bought one, fooled around with it on his 1969 solo release *Electronic Sound*, then played it on 'Here Comes the Sun', 'Maxwell's Silver Hammer', 'Oh! Darling', 'Octopus' Garden' and John's Yoko-inspired 'Because' and 'I Want You (She's So Heavy)'.

3. 28IF numberplate
In the famous 'Paul is dead' Beatles conspiracy theory the white Volkswagen Beetle in the background had a license plate LMW 28IF, meaning 'Linda McCartney Weeps'/ '28 IF Paul had lived' (though Paul was actually 27).

4. Red Hot Chili Peppers
The psychedelic funk punks spoofed the cover for their 1988 *Abbey Road* EP. They often performed nude except for tube socks.

5. Yoko in bed
After getting married on March 29, John and Yoko decided to use their honeymoon as their first 'Bed-In for Peace'. Unfortunately, Yoko was badly hurt in a car crash, so John had a bed brought into the studio for her during the recording of *Abbey Road*.

6. Ringo's octopus
After briefly quitting the band, Ringo wrote a song imagining a utopia free from Paul's criticisms. Then Ringo received a telegram that read, 'You're the best rock 'n' roll drummer in the world. Come on home, we love you'. When he got back to the studio his drums were covered in flowers.

BONUS

7. Chuck Berry
John used one line of Chuck's 'You Can't Catch Me'. Berry's publisher Morris Levy sued. John settled by agreeing to record a number of the publisher's songs on his solo album of oldie covers, *Rock and Roll*.

8. Polythene Pam
Two females inspired John's character: a fan from the Cavern days who used to eat plastic, and the girlfriend of Beat poet Royston Ellis who one night dressed up in polythene.

9. Ray Charles
For 'Something', George pretended to be soul genius Ray Charles, just as Paul had when he wrote 'She's a Woman' and 'The Long and Winding Road'.

10. Frank Sinatra
Ol' Blue Eyes called 'Something' 'the greatest love song of the past 50 years', though he erroneously attributed it to Lennon–McCartney.

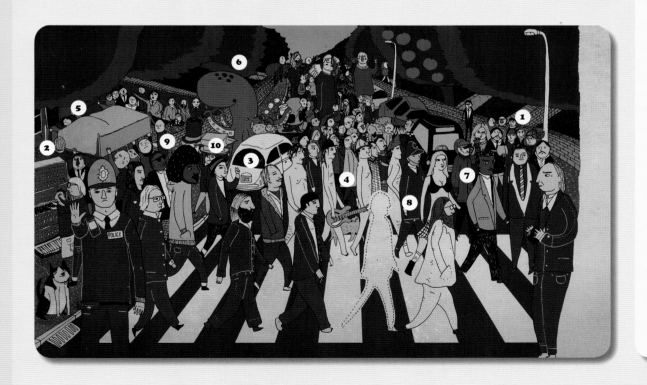

Where's Ringo?
Timeline

1940s

July 7, 1940
Richard Starkey, Jr., is born in Liverpool, England, in the home of his parents, confectioners Richard Starkey, Sr., and Elsie (Gleave) Starkey.

Summer 1947
Richie's burst appendix becomes infected with peritonitis and puts him in a coma for ten weeks, then keeps him in the Royal Liverpool Children's Hospital until the summer of 1948.

1950s

May 1954
Richie's pleurisy turns into tuberculosis and he must stay in a sanatorium until the end of 1955. Inside he discovers drumming and plays with the hospital band.

1956
Richie becomes an apprentice machinist and forms the Eddie Clayton Skiffle Group with other workers.

December 25, 1956
Richie's stepfather Harry Graves gives him a second-hand drum kit.

March 25, 1959
Richie joins Al Caldwell's Texans and takes the stage name Ringo Starr because of its Western sound and because he wears a lot of rings. The group later renames themselves Rory Storm and the Hurricanes.

1960s

October 1, 1960
The Hurricanes arrive in Hamburg, Germany, to share the bill at the Kaiserkeller club with the Beatles, and Ringo meets John, Paul, George, Stu, and Pete for the first time. He sits in with them occasionally when Pete is unavailable.

August 14, 1962
John asks Ringo to join the Beatles.

August 18, 1962
Ringo plays his first gig with the group in Birkenhead, England.

September 4, 1962
Ringo's first recording session with the Beatles, in which the group worked on 'Love Me Do'.

March 23, 1963
Please Please Me is released and includes Ringo's cover of the Shirelles' 'Boys'. 'Boys' is issued as a single in the US in fall 1964 and makes it to No. 102.

November 4, 1963
The Beatles play for the Queen at the Royal Command Performance.

November 22, 1963
With the Beatles contains Ringo's rendition of John and Paul's 'I Wanna Be Your Man'.

February 9, 1964
The Beatles debut on *The Ed Sullivan Show*, igniting Beatlemania in the US.

April 9, 1964
Badly hungover, Ringo ad libs his solo scenes in the feature *A Hard Day's Night* in which he befriends a young boy.

July 6, 1964
Ringo earns widespread praise for his performance in *A Hard Day's Night*. A quip of his inspired the title.

August 24, 1964
Ringo's cover of Carl Perkins' 'Matchbox' reaches No. 17 as a US single.

December 9, 1964
Beatles For Sale features Ringo's cover of Carl Perkins' 'Honey Don't'.

February 11, 1965
Ringo marries Maureen Cox, whom he met at the Cavern Club in 1962.

February 18, 1965
Ringo records John and Paul's 'If You've Got Trouble', unreleased until 1996's *Anthology 2*. Oasis borrowed the riff for 1994's 'Up in the Sky'.

July 29, 1965
The film *Help!* centers around Ringo.

August 6, 1965
The *Help!* album features Ringo's cover of Buck Owens' 'Act Naturally'. It also reaches No. 47 as the B-side to 'Yesterday' in the States.

September 13, 1965
Ringo's son Zak is born.

September 25, 1965
The Beatles Saturday morning cartoon debuts and airs through May 9, 1969.

October 26, 1965
Queen Elizabeth II appoints the Beatles Members of the Order of the British Empire (MBE) at Buckingham Palace.

December 3, 1965
On *Rubber Soul*, Ringo sings a song John wrote in the '50s, 'What Goes On', and receives co-writing credit for adding five words. As the B-side to 'Nowhere Man' in the States it makes it to No. 81.

August 5, 1966
Ringo hits No. 1 in the UK singing lead on the single 'Yellow Submarine', written by Paul; it charts at No. 2 in the US. The song is included in *Revolver* along with 'Tomorrow Never Knows', its title inspired by a phrase of Ringo's. Ringo contributed a verse to 'Eleanor Rigby', as well.

August 29, 1966
The Beatles wrap their final concert tour at Candlestick Park in San Francisco.

June 1, 1967
Sgt. Pepper's Lonely Hearts Club Band spotlights Ringo singing John and Paul's 'With a Little Help From My Friends'. Ringo recorded his vocal with the others at dawn, weary from an all-night recording session.

August 19, 1967
Ringo's second son, Jason, is born.

November 27, 1967
The soundtrack to the Beatles' telefilm *Magical Mystery Tour* includes 'Flying', credited to all Beatles as songwriters.

July 17, 1968
Ringo enlists the other Beatles to fight the Blue Meanies in the animated feature *Yellow Submarine*.

November 22, 1968
The White Album contains Ringo's first solo composition, 'Don't Pass Me By', also released as the B-side to 'Back in the U.S.S.R.' in 1976. Ringo sings John's lullaby 'Good Night', as well.

December 17, 1968
Ringo debuts in his first film without the other Beatles, *Candy*.

January 30, 1969
The Beatles give their final live performance on the Apple rooftop for the *Let It Be* film.

August 8, 1969
Ringo records his only Beatle drum solo on *Abbey Road*'s 'The End'.

September 20, 1969
John tells the others he is quitting the Beatles.

September 26, 1969
Abbey Road is released, featuring Ringo's composition 'Octopus' Garden', which he wrote on Peter Sellars' yacht when he briefly quit the band during *The White Album* sessions.

December 12, 1969
Ringo stars with Peter Sellars in *The Magic Christian*.

1970s
March 27, 1970
Ringo's first solo album *Sentimental Journey* makes it to No. 7 in the UK.

April 1, 1970
Ringo, George, and Paul record 'I Me Mine' without John, the final Beatle session.

April 10, 1970
Paul's press release for his first solo album *McCartney* announces the Beatles have split up.

May 8, 1970
The *Let It Be* album is released, featuring 'Dig It' credited to all four Beatles.

May 13, 1970
The documentary feature *Let It Be* is released.

October 5, 1970
Ringo issues the country album *Beaucoups of Blues*, recorded in Nashville.

November 11, 1970
Ringo's daughter Lee Parkin Starkey is born.

November 27, 1970
Ringo drums on a number of tracks on George's first solo album *All Things Must Pass*.

December 11, 1970
Ringo drums on all songs of John's first solo album *John Lennon / Plastic Ono Band*.

April 9, 1971
Ringo's single 'It Don't Come Easy', co-written with George, reaches No. 2 in the UK and No. 9 in the US. The B-side, 'Early 1970', expressed Ringo's hopes for a Beatles reunion.

August 1, 1971
Ringo drums and sings at George's Concert for Bangladesh.

March 17, 1972
Ringo's self-penned single 'Back Off Boogaloo' makes No. 2 in the UK and No. 9 in the US. The flipside is the theme to his 1971 spaghetti Western *Blindman*.

December 18, 1972
Ringo directs the feature documentary *Born To Boogie* about glam rocker Marc Bolan.

April 12, 1973
That'll Be the Day features Ringo's most acclaimed post-Beatles film performance, in a story about the singer of a band called the Stray Cats based on the early Beatles and Hurricanes.

October 5, 1973
'Photograph', co-written with George, tops the charts in the US and reaches No. 8 in the UK.

November 2, 1973
The album *Ringo* goes to No. 2 in the US and No. 7 in the UK. Ringo plays with John and George on 'I'm the Greatest' and with Paul on 'Six O'Clock'.

February 2, 1974
Ringo's proto-disco 'Oh My My' hits No. 5 in the US.

February 8, 1974
Ringo's cover of 'You're Sixteen' is his second solo No. 1 single in the US and climbs to No. 2 in the UK.

April 19, 1974
Ringo acts alongside best friend Harry Nilsson in the legendarily bad *Son of Dracula*.

November 15, 1974
Goodnight Vienna, with title track written by John, reaches No. 8 in the US and No. 30 in the UK. He covers the Platters' 'Only You' with John's help and scores a No. 6 in the US.

January 27, 1975
'The No No Song' backed by 'Snookeroo' (featuring Elton John) makes No. 3 and caps his streak of seven consecutive Top 10 singles in the US.

July 17, 1975
Ringo divorces Maureen Cox Starkey.

April 26, 1978
The hour-long US television special *Ringo* airs.

1980s
April 27, 1981
Ringo marries actress Barbara Bach a year after meeting her while filming *Caveman*.

May 11, 1981
Ringo and Paul reunite with George for the tribute single to John 'All Those Years Ago', which goes to No. 2 in the US.

September 4, 1984
Ringo narrates the first two seasons of the children's TV show *Thomas the Tank Engine and Friends*.

October 22, 1984
Ringo acts in Paul's feature *Give My Regards to Broad Street* and drums on the soundtrack.

January 25, 1988
Ringo drums on George's Beatle tribute 'When We Was Fab', making it to No. 23 in the US and 25 in UK.

January 29, 1989
Ringo plays Mr. Conductor in the *Shining Time Station* TV show for one season.

July 23, 1989
Ringo and his first All-Starr Band debut in Dallas to ten thousand fans. The first line-up includes Nils Lofgren and Clarence Clemons (Bruce Springsteen's E Street Band), Rick Danko and Levon Helm (The Band), Joe Walsh (The Eagles), Billy Preston, Dr. John, and drummer Jim Keltner. There will be 12 more incarnations of the All-Starr Band over the next 25 years.

1990s
May 22, 1992
Ringo's comeback album *Time Takes Time* includes his Beatles tribute 'After All These Years'.

December 4, 1995
Ringo, Paul, and George reunite to accompany John's demo 'Free as a Bird' which makes it to No. 2 in the UK and No. 6 in the US. It accompanies *The Beatles Anthology* albums and TV mini-series.

March 4, 1996
'Real Love', the Beatles' second reunion single built around John's demo, hits No. 4 in the UK and No. 11 in the US.

2000s
October 25, 2003
Ringo releases his tribute to George, 'Never Without You', accompanied by Eric Clapton.

December 12, 2009
Paul joins Ringo for the single 'Walk With You'.

February 8, 2010
Ringo receives a star on the Hollywood Walk of Fame in front of Capitol Records alongside John, Paul, and George's stars.

July 7, 2010
Paul joins Ringo and the All-Starr Band onstage for Ringo's 70th birthday at Radio City Music Hall.

October 5, 2011
Ringo and Paul appear in Martin Scorsese's documentary *George Harrison: Living in the Material World*.

February 9, 2014
Ringo and Paul reunite for *The Night That Changed America: A Grammy Salute to the Beatles* on the 50th anniversary of their Ed Sullivan debut.

Where's Ringo?

Index

Where's Ringo?

Acknowledgments

I will always be grateful to Mark Searle and Sonya Ellis for giving me the opportunity to work on this book and to Emma Bastow for guiding the project through. I was incredibly fortunate to have the indefatigable Bruno Vincent as Project Editor to pull the text together with all the amazing illustrations by Oliver Goddard, Takayo Akiyama, and David Ryan Robinson. I would also like to thank Quintet's Michael Charles, Ella Lines, Alice Sambrook, Lucy Parissi, Quarto's Andrew Compton, Baker and Taylor's Ginger Winters, and Mark Hudson. As always I am obliged to the priceless counsel of my agent Charlie Viney and Sally Fricker of the Viney Company. Thanks to Dad for playing *Abbey Road* when we cruised around, to Mom for buying all those Beatle books, and to Keira for the twisting and shouting.